This Book is dedicated to all family and friends that have always inspired and supported my art. To all of them past and present keep creating.

Thank you, JV

JV Creative Copyright 2016

All images in this book are property of Jose Villalba no use of these images in any way is permitted without written permission.

Contact me at jvillalba1979@hotmail.com

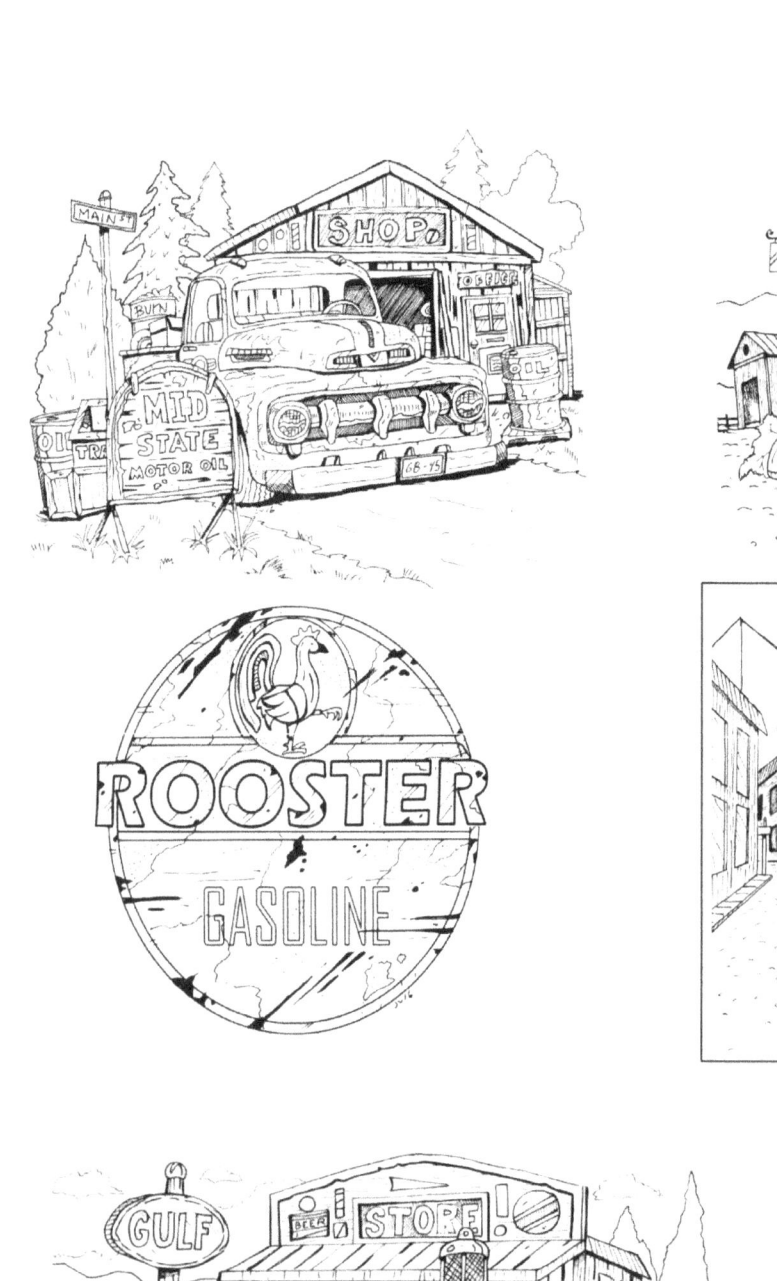
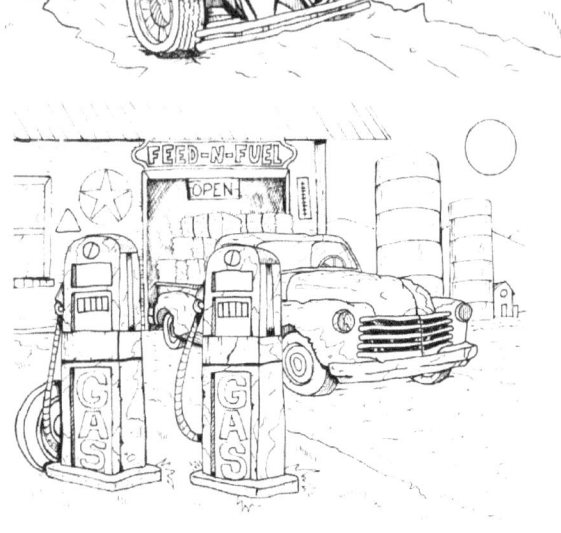
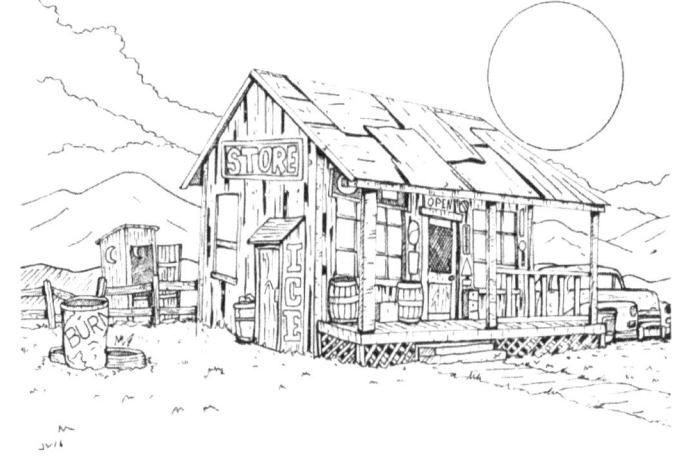

This Book is dedicated to all my family and friends who have always supported and inspired my art and creativity. JV

The images in this book are all original hand drawings by me; I took the images and created them in different forms and lay outs for your enjoyment, tend to like the more handmade look when it comes to drawings and coloring books. This book is a car lover dream, if you like old cars, and you like old rustic scenes….this book is for you.

We suggest that the colorist use some sort of backing like cardboard when coloring to prevent bleed through, especially when using markers.

All of the images on this book are subject to copyright and belong to JV Creative and or Jose Villalba. No reproduction or the use of these images for resale is permitted without the written permission of Jose Villalba.

If you have any questions or wish to contact me do so at:

Jvillalba1971@hotmail.com

JVCreative@hotmail.com

You can also message me and check out more of my projects and artwork at:

Facebook, look for JVCretive artist.

On Etsy at JVCreative.

Thank you for your support……..and keep coloring. JV
Look for my other books, Old Country Road, and Aztec and Mayan inspired designs, Cat Country,

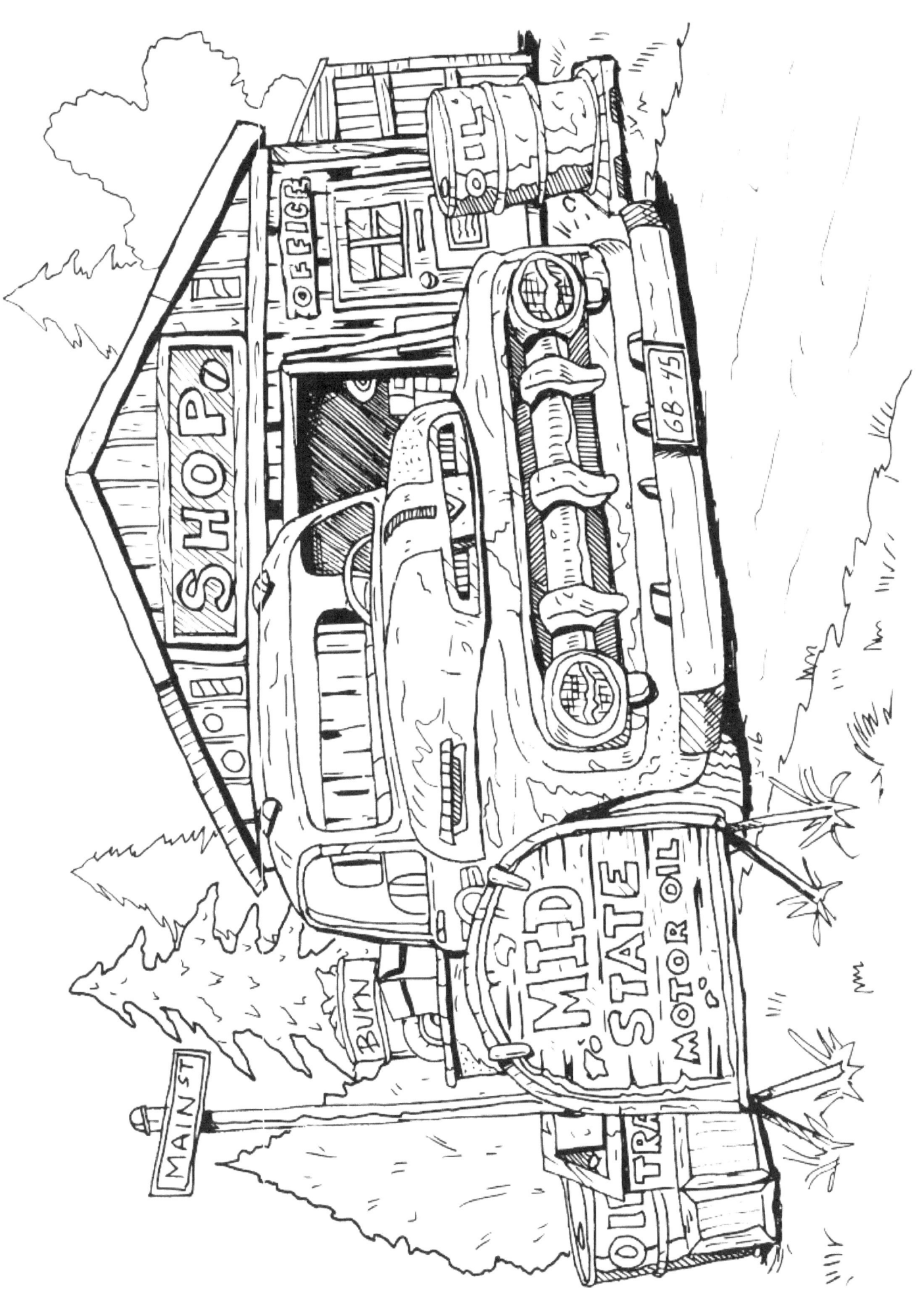

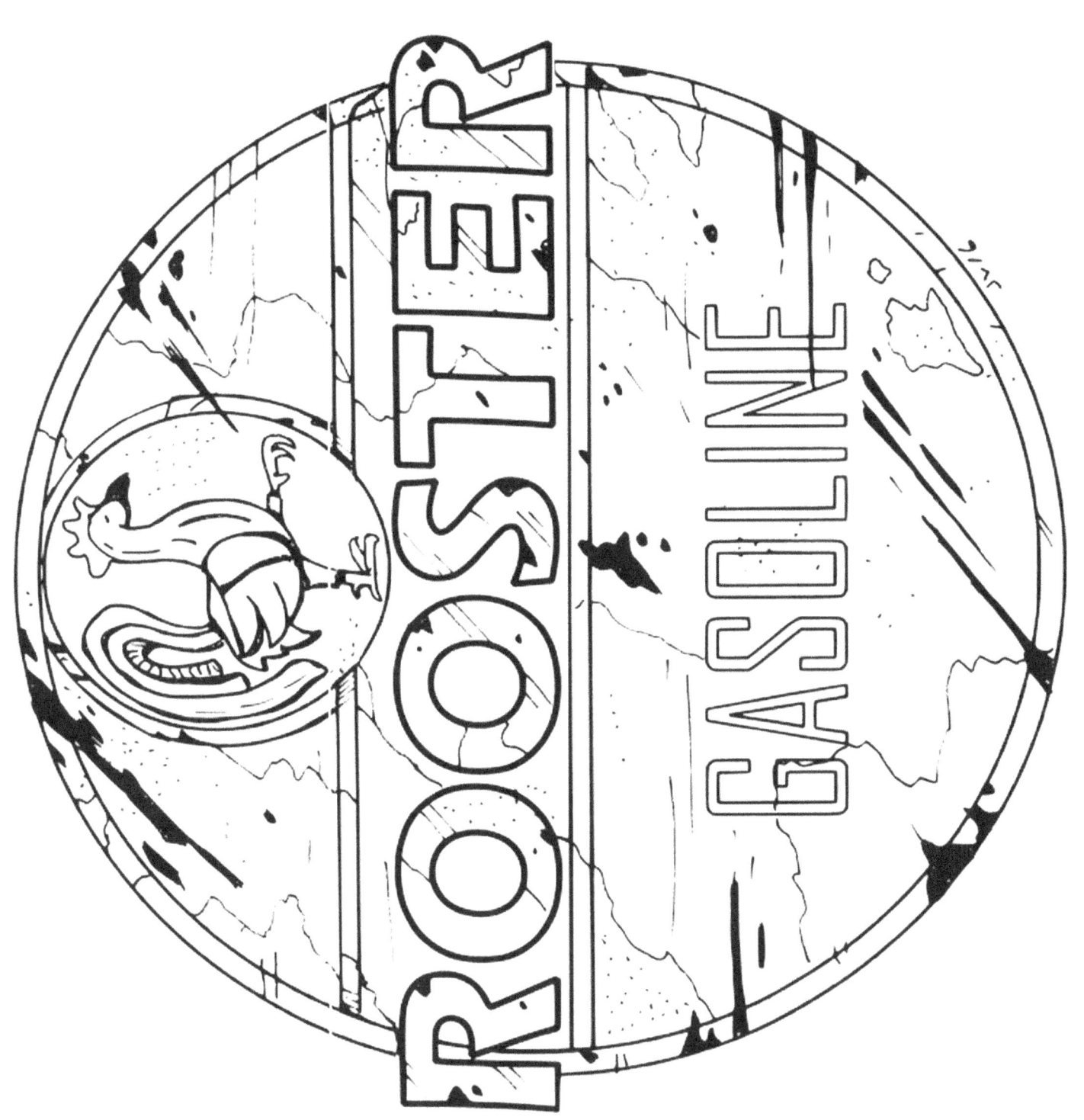

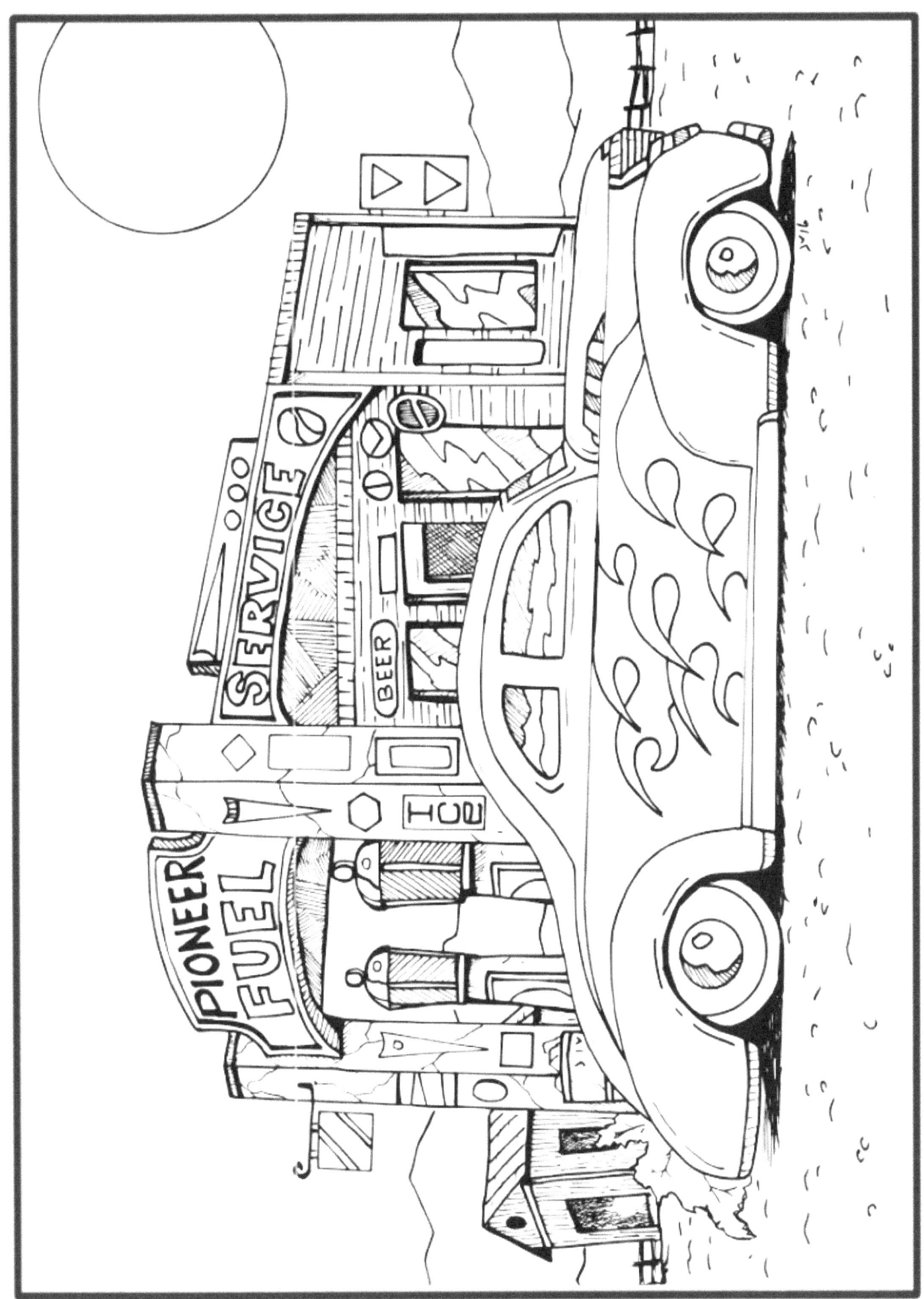

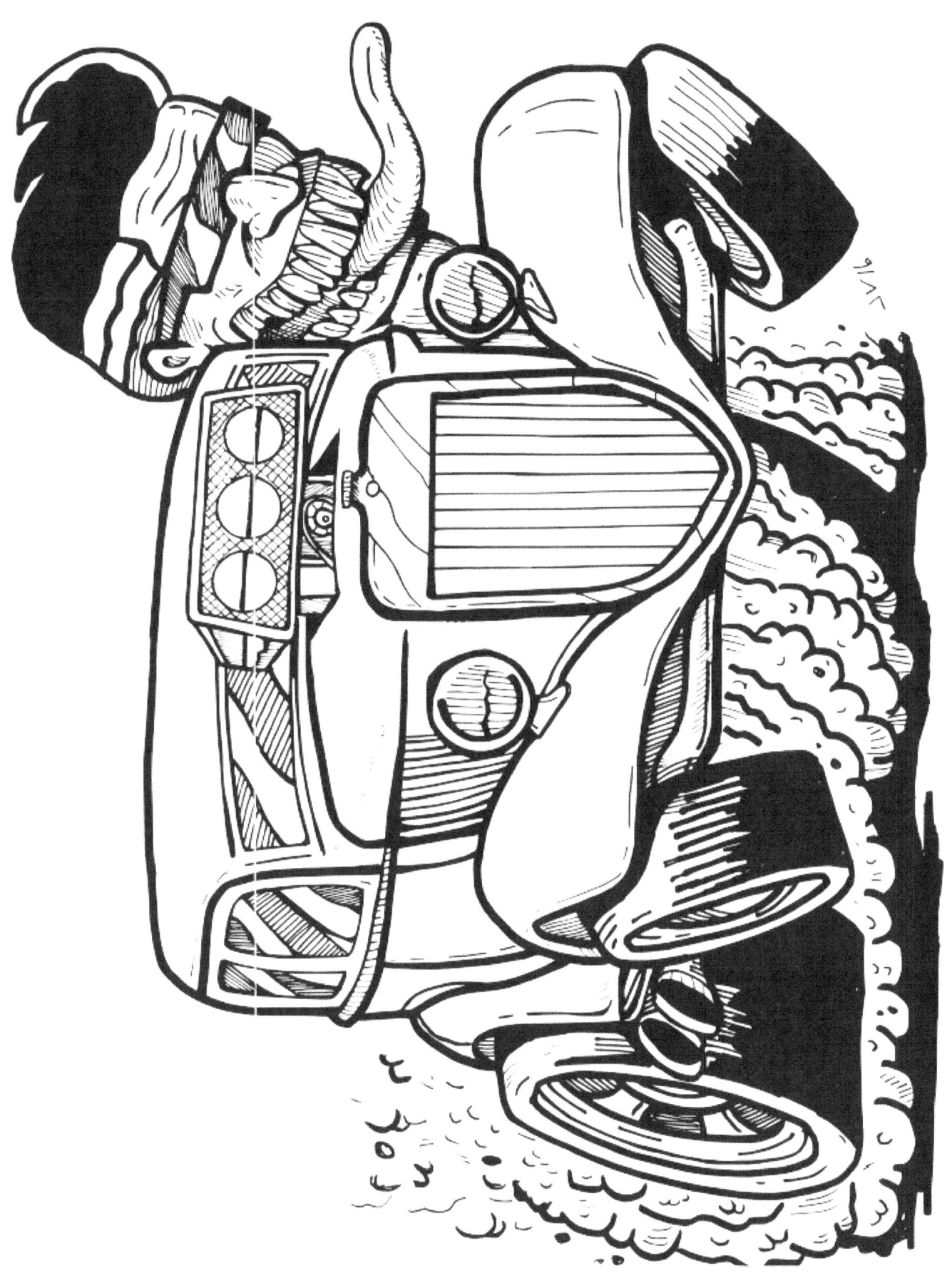

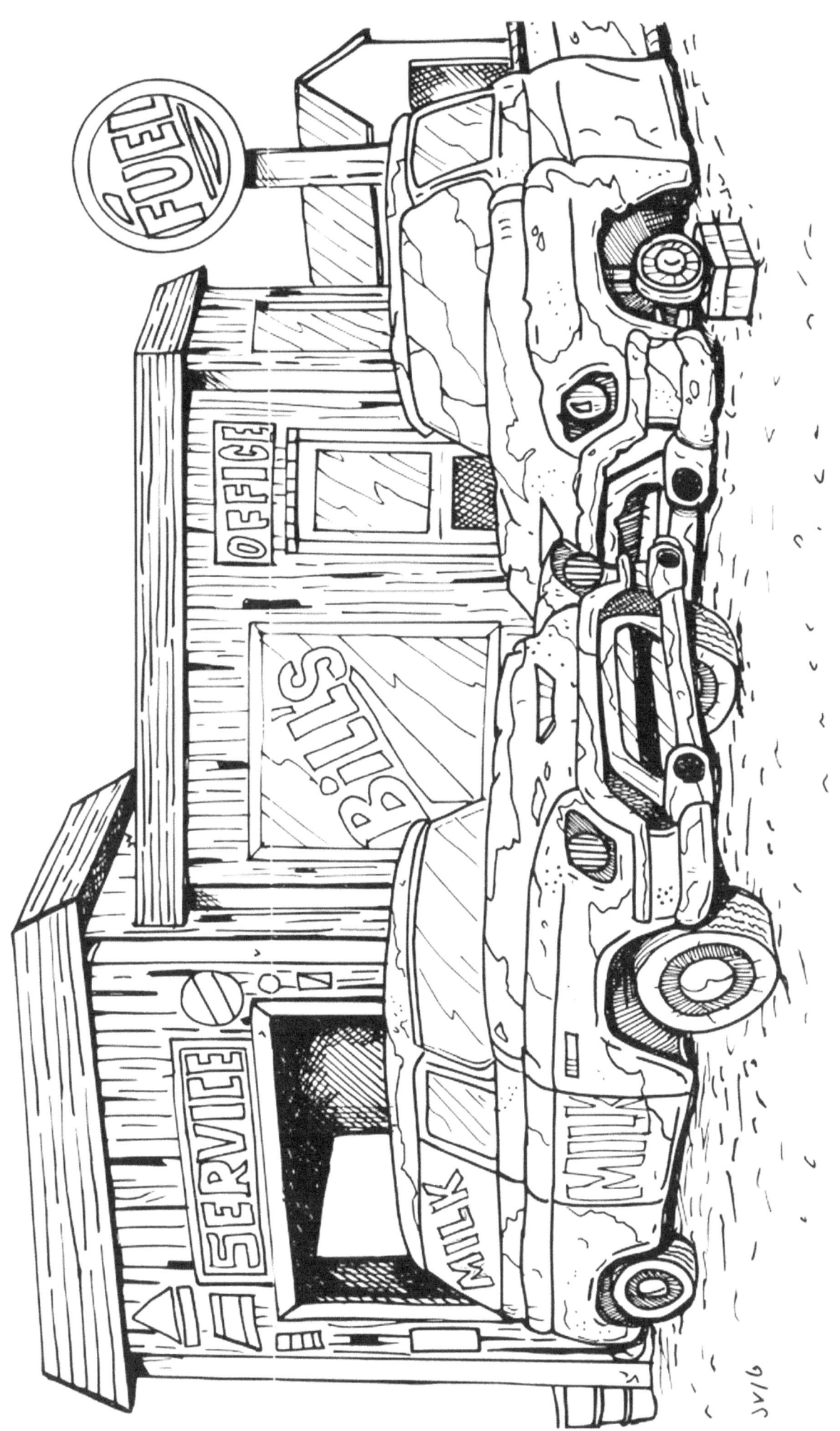

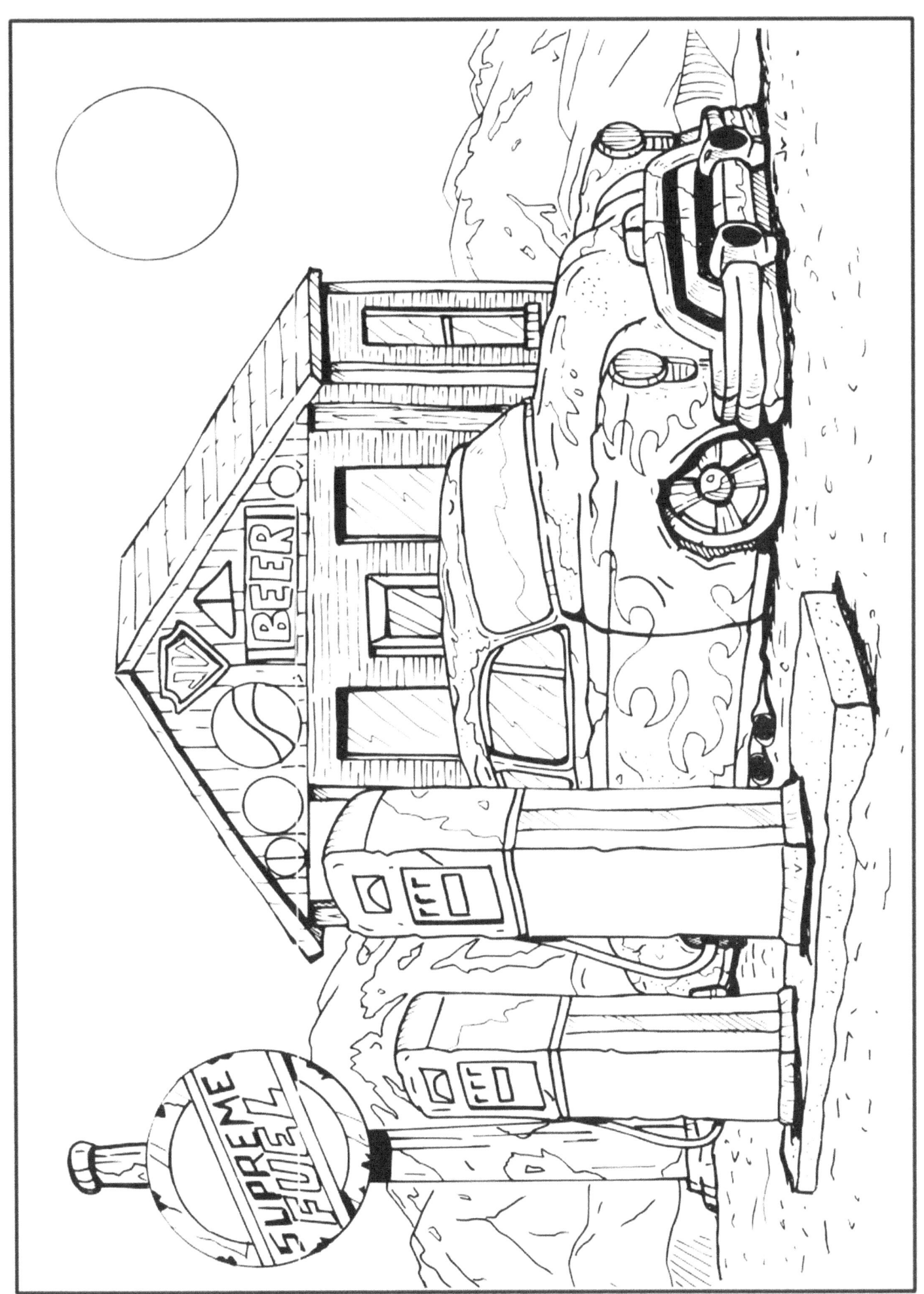

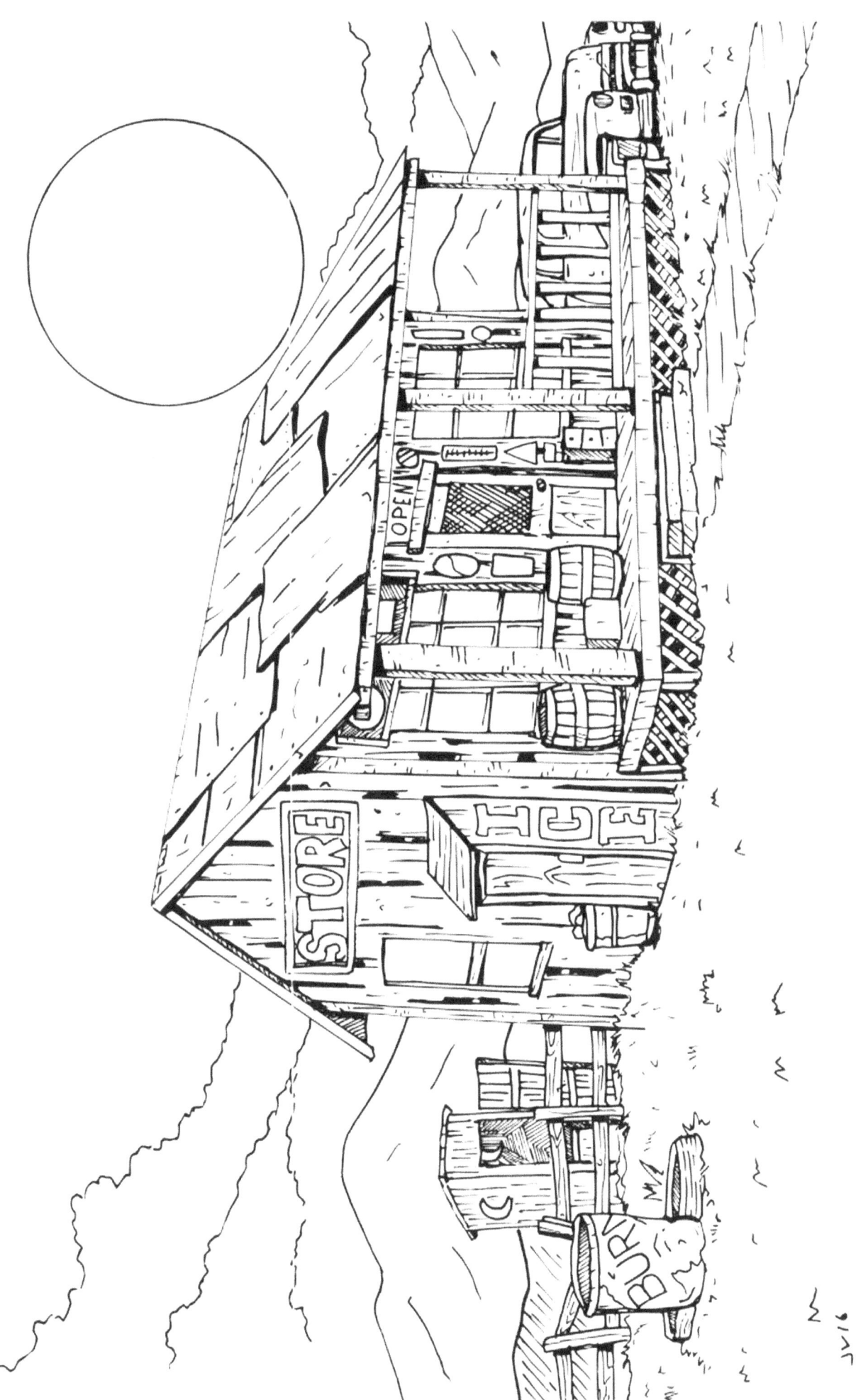

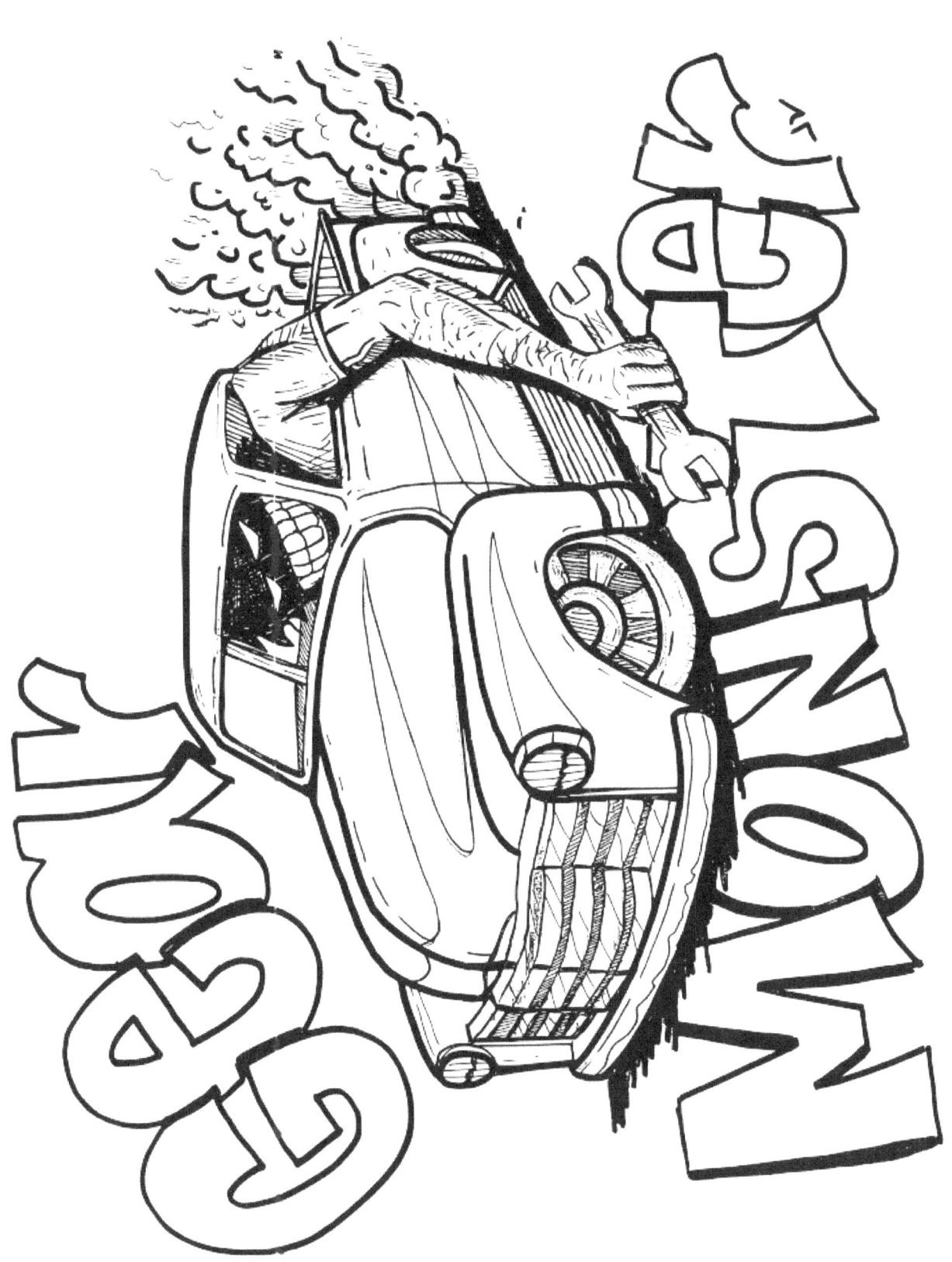

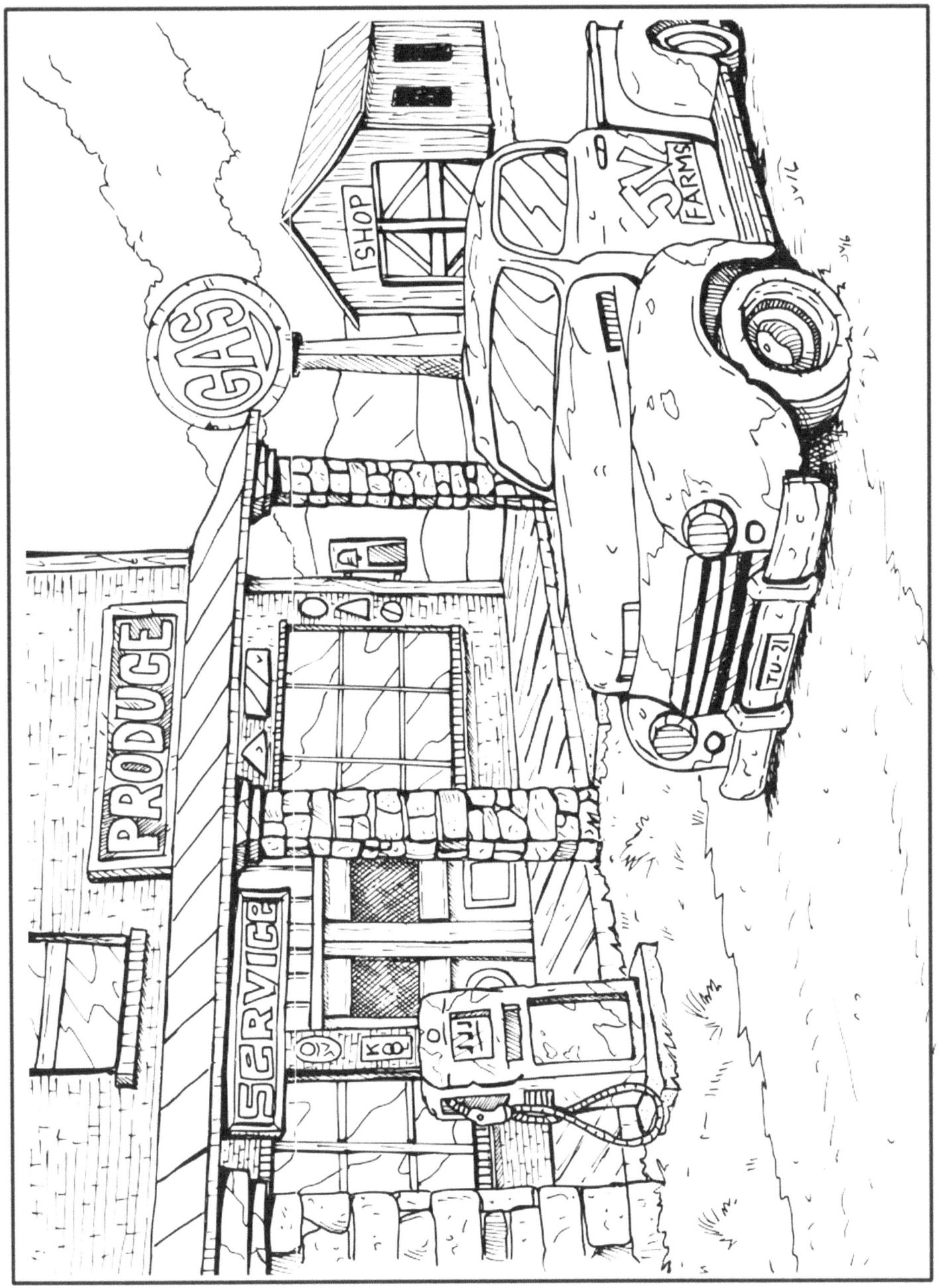

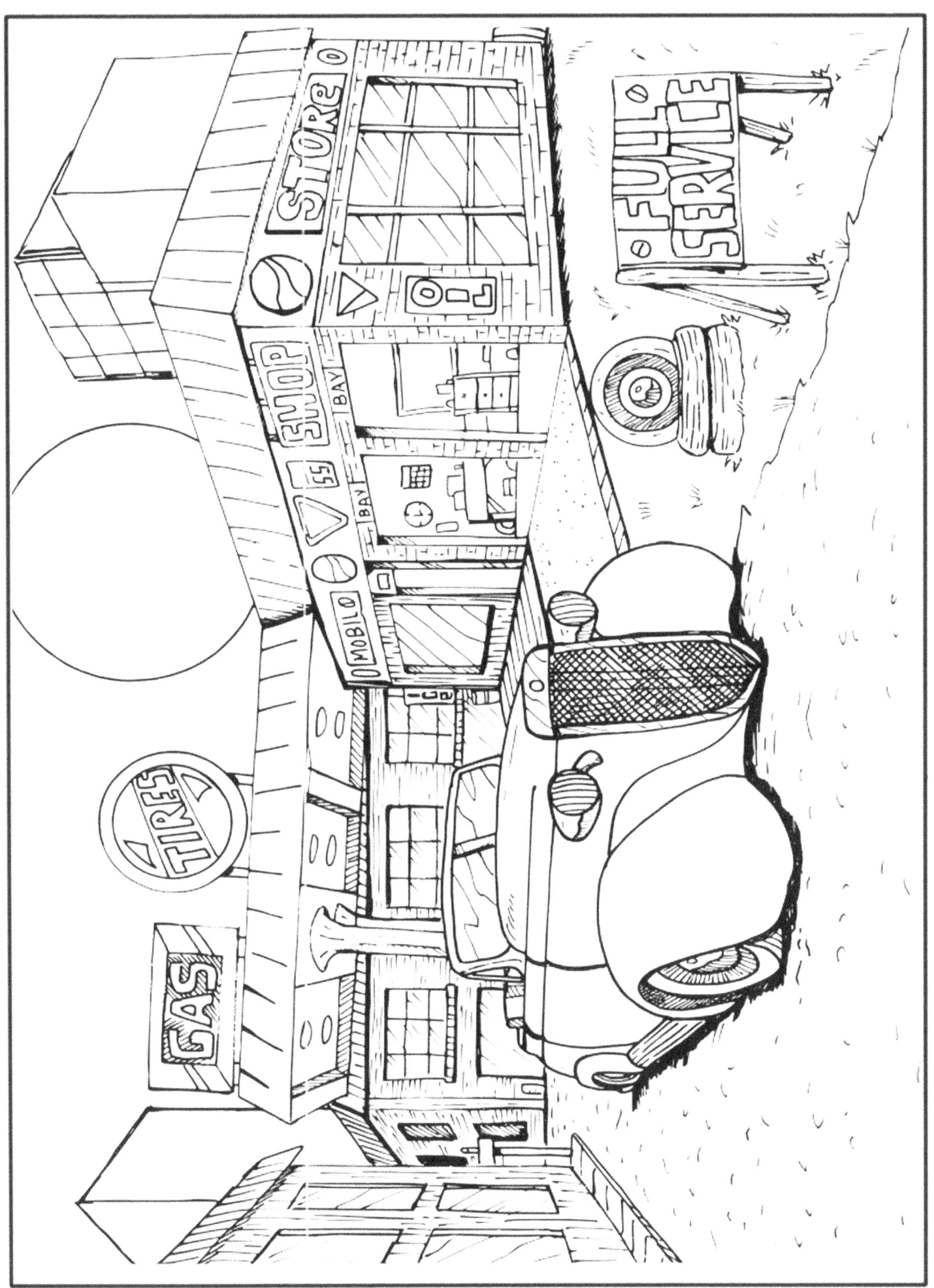

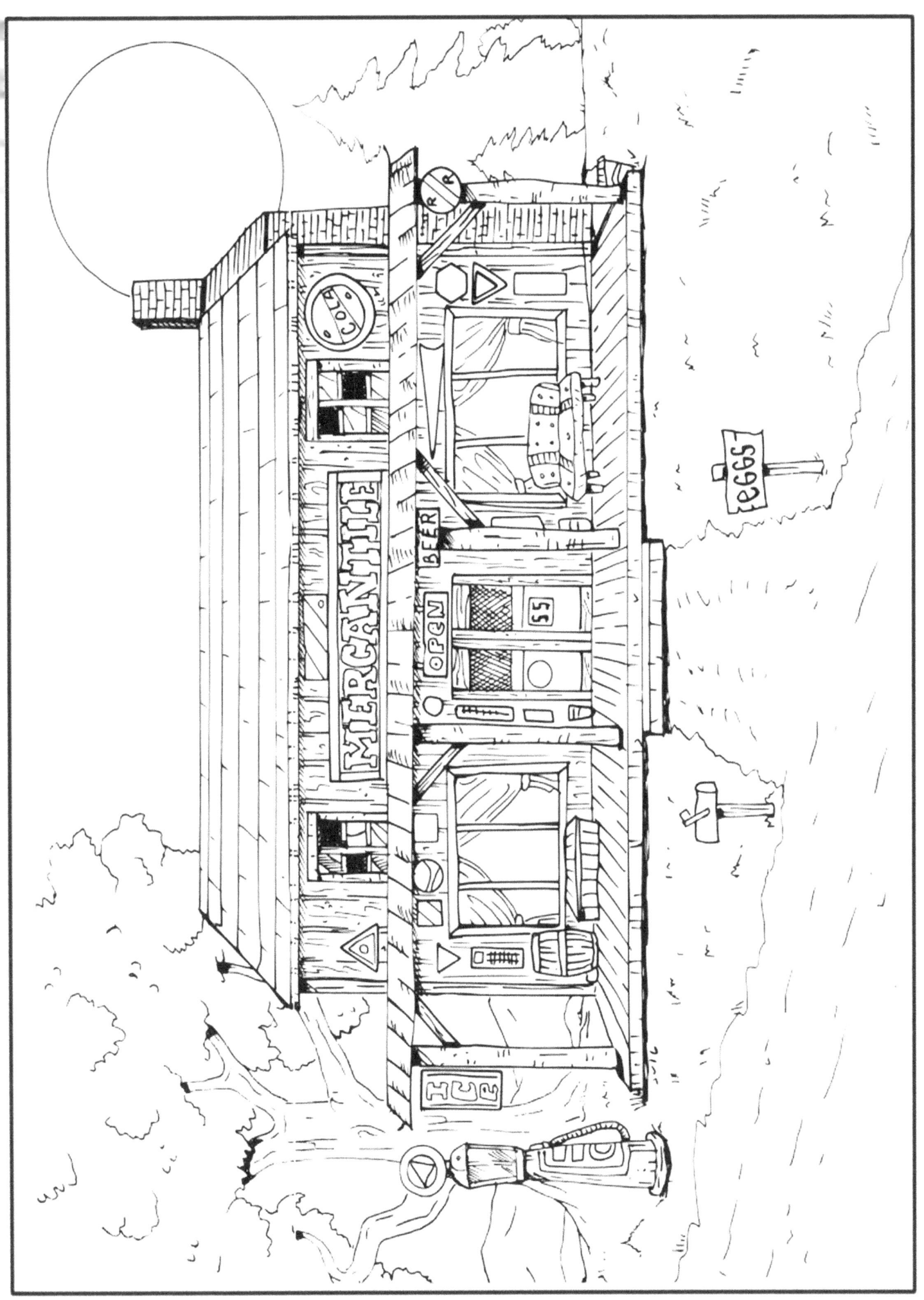

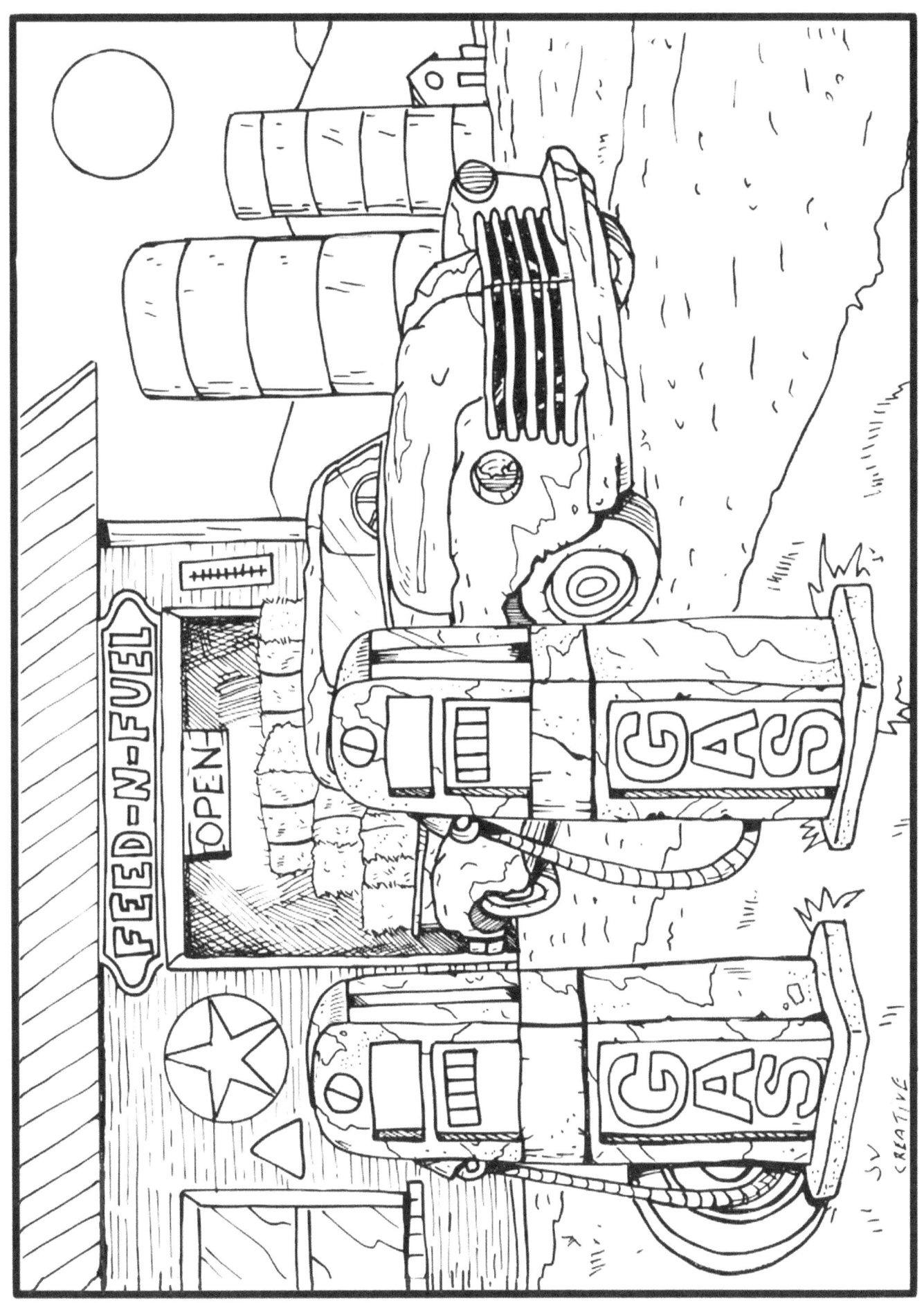

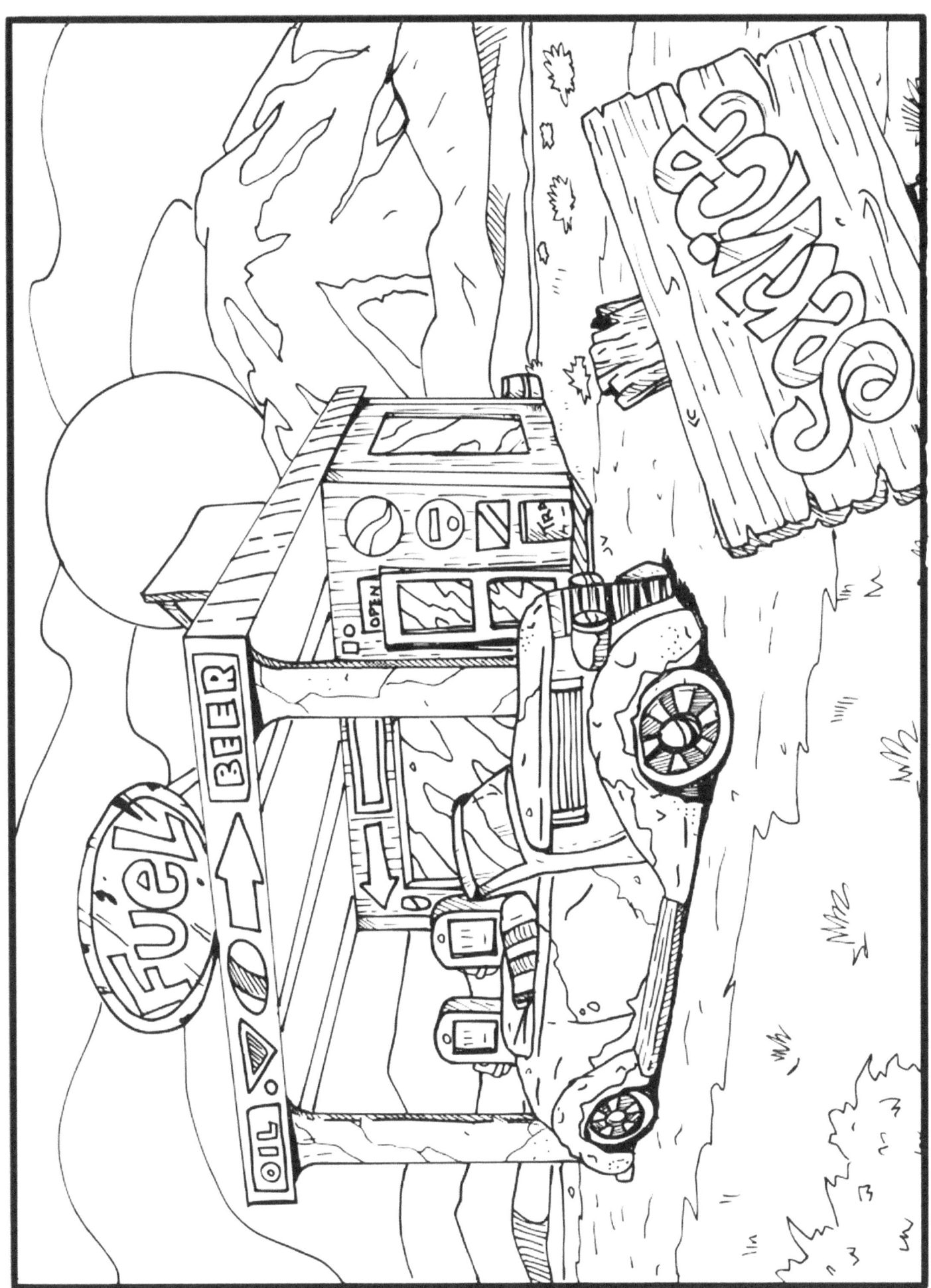

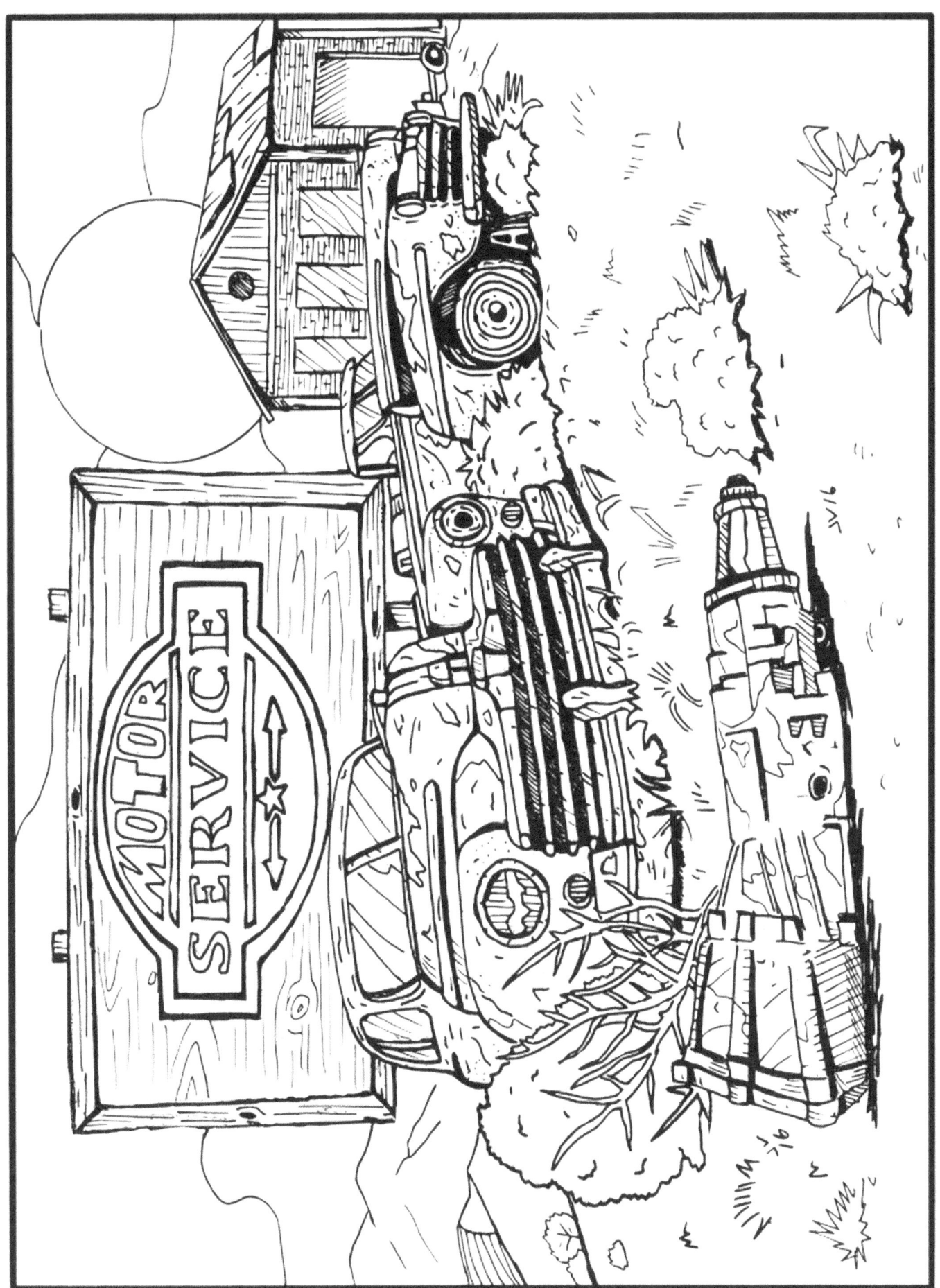

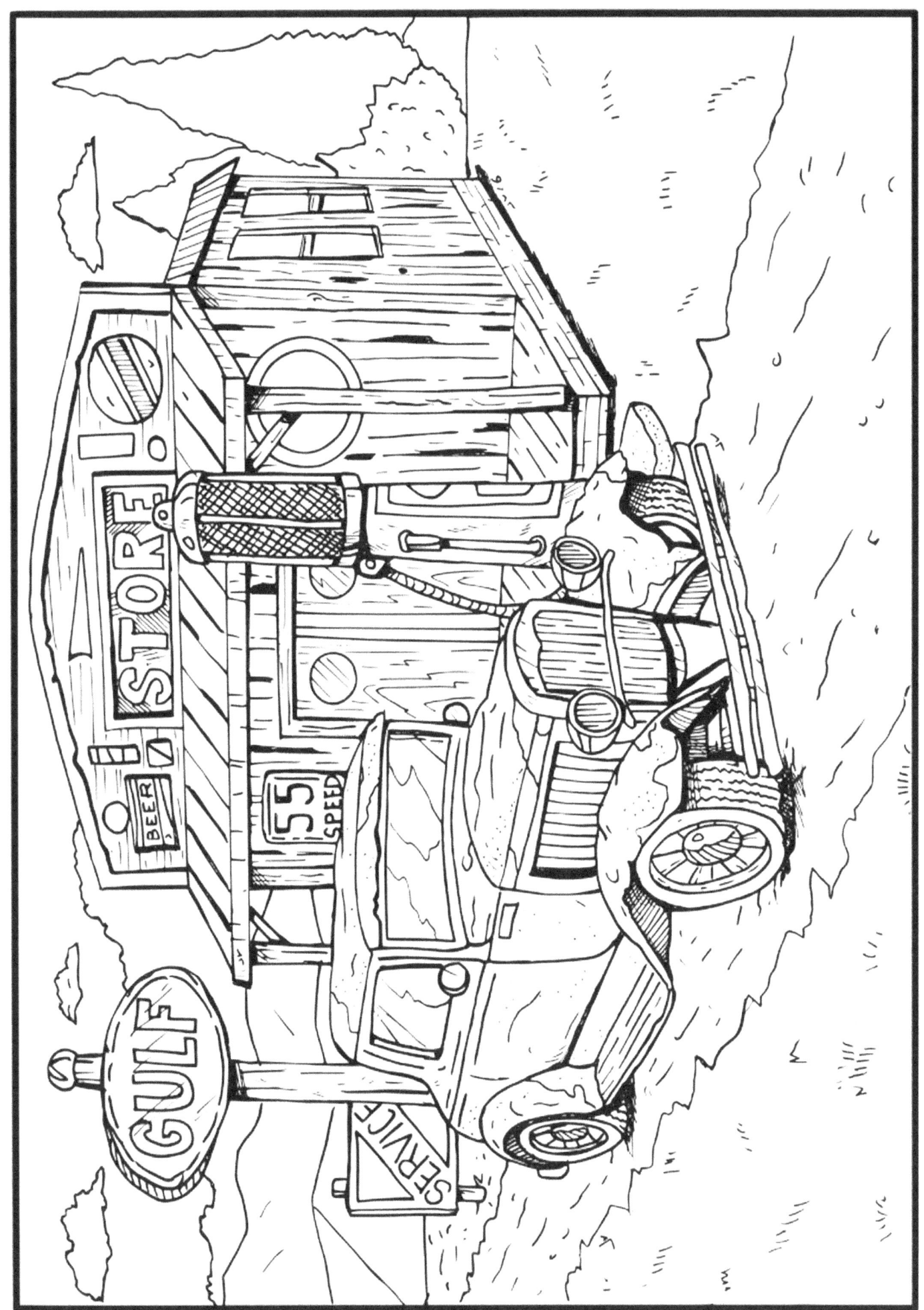

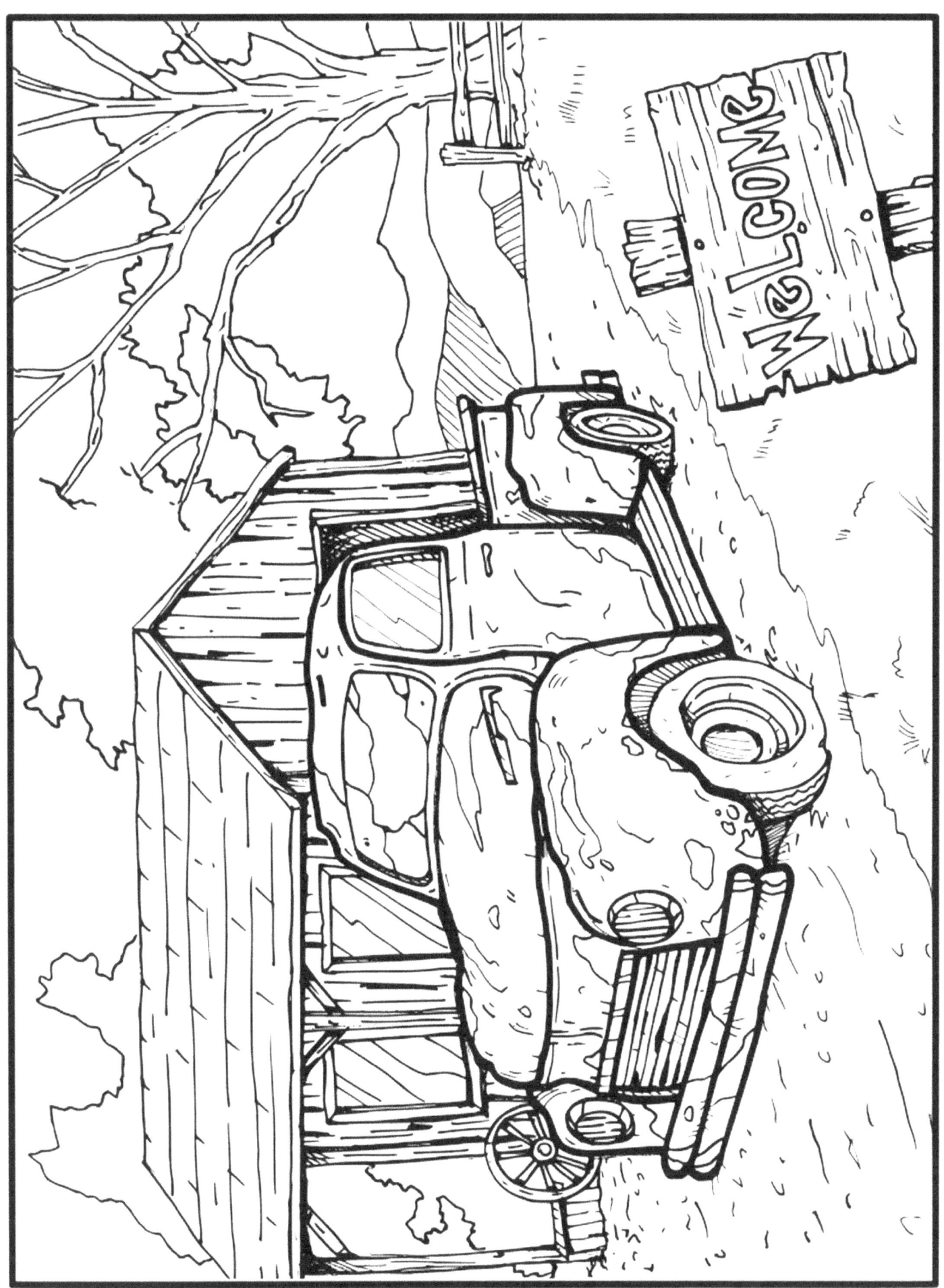

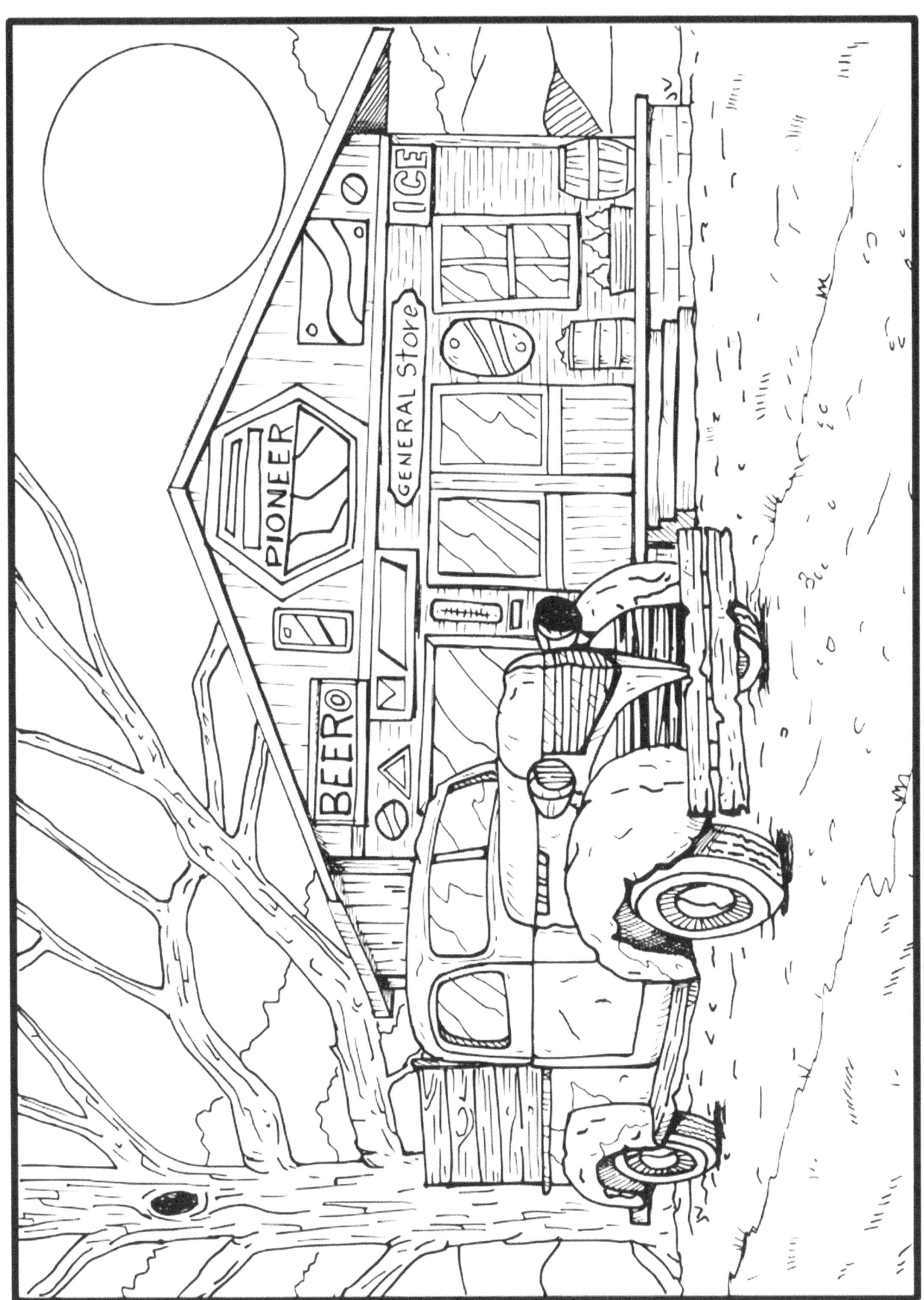

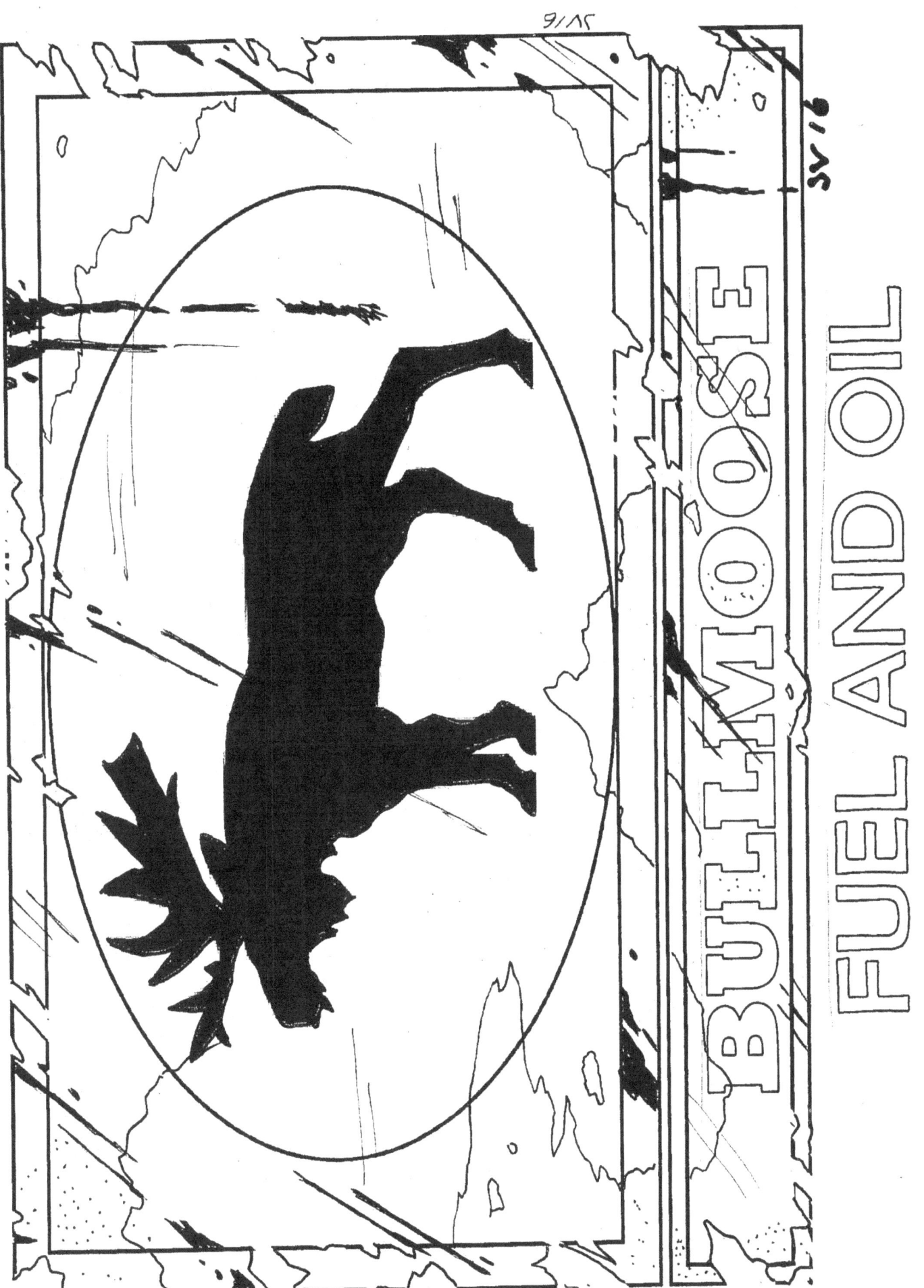

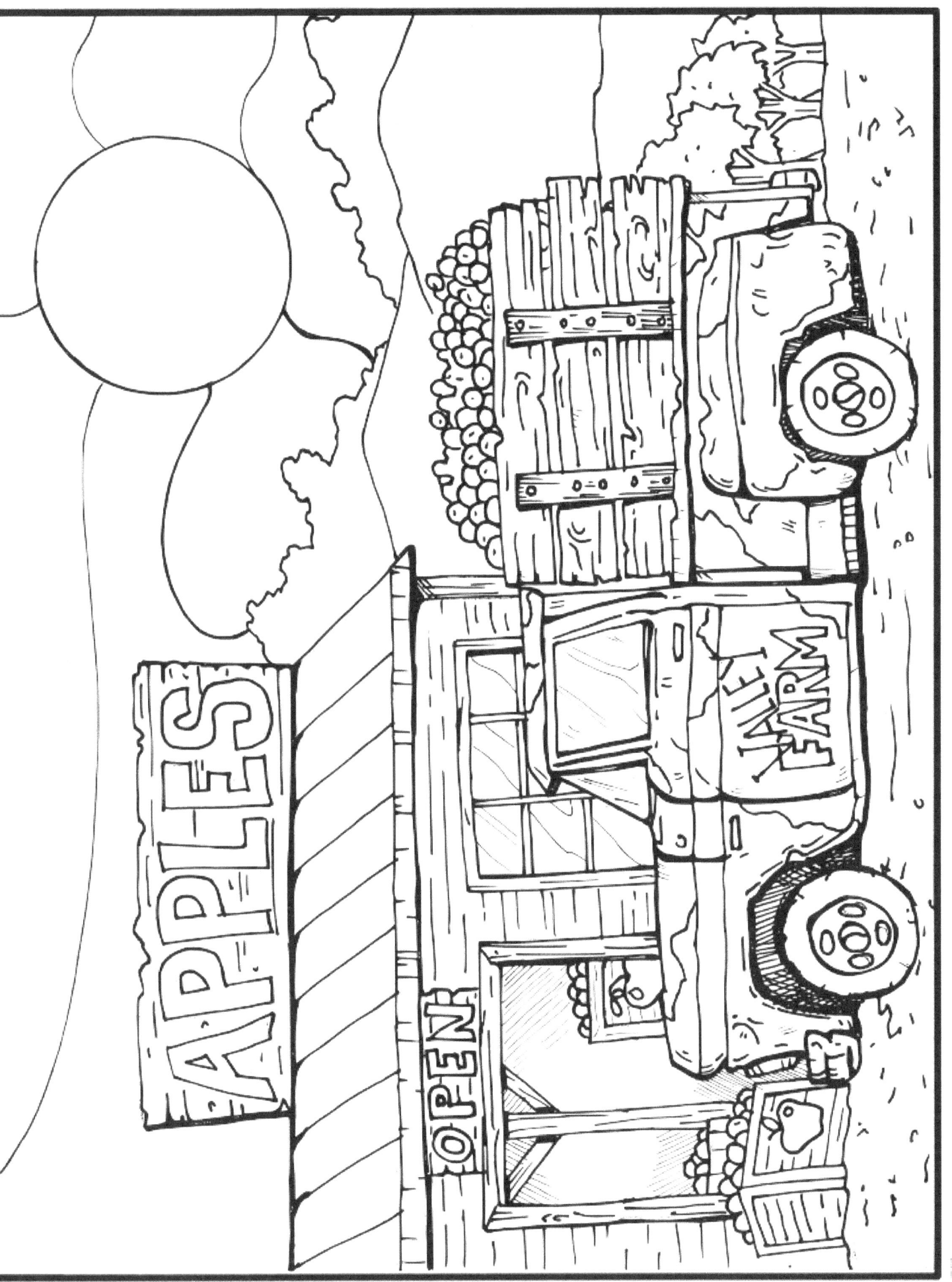

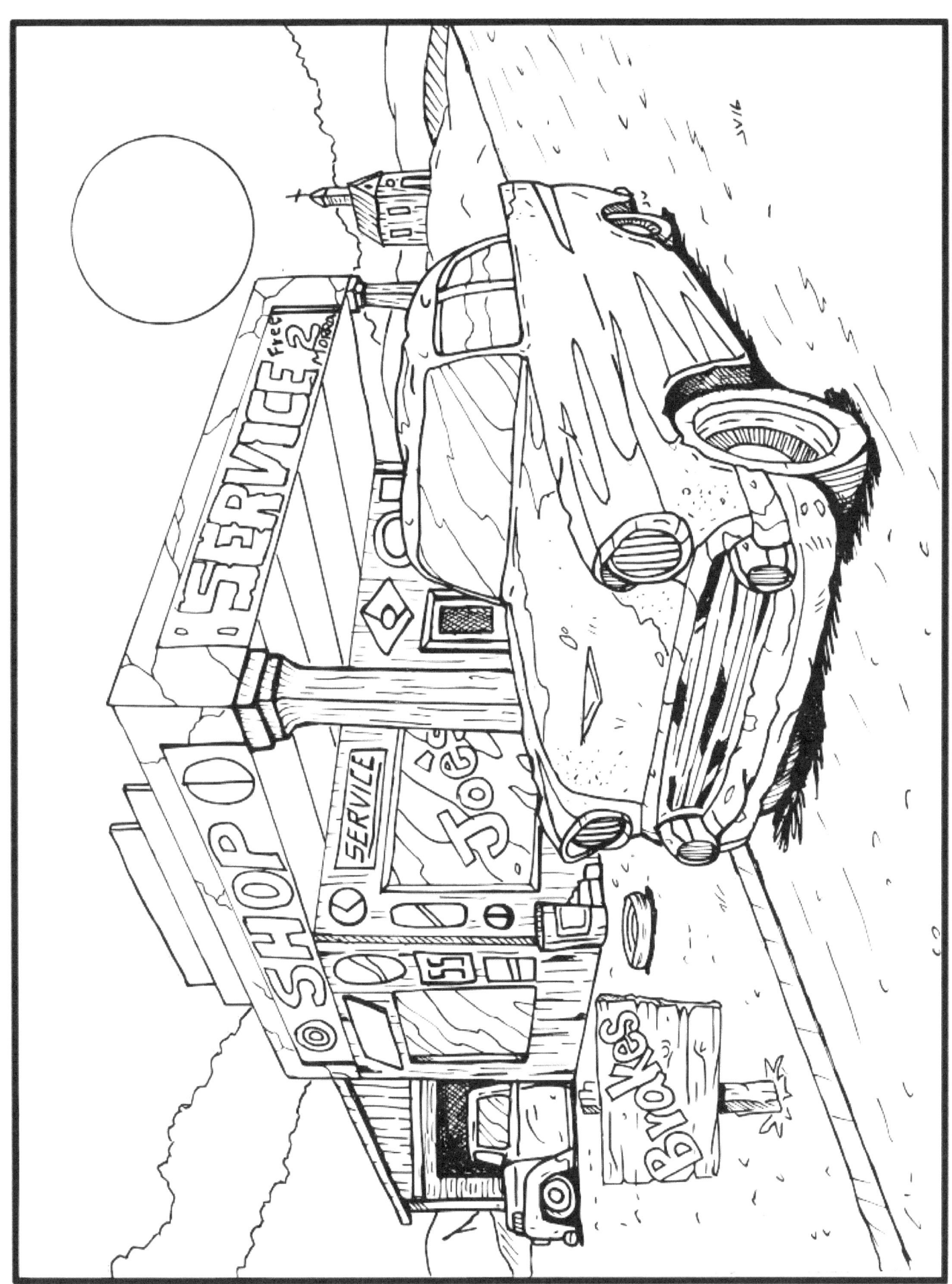

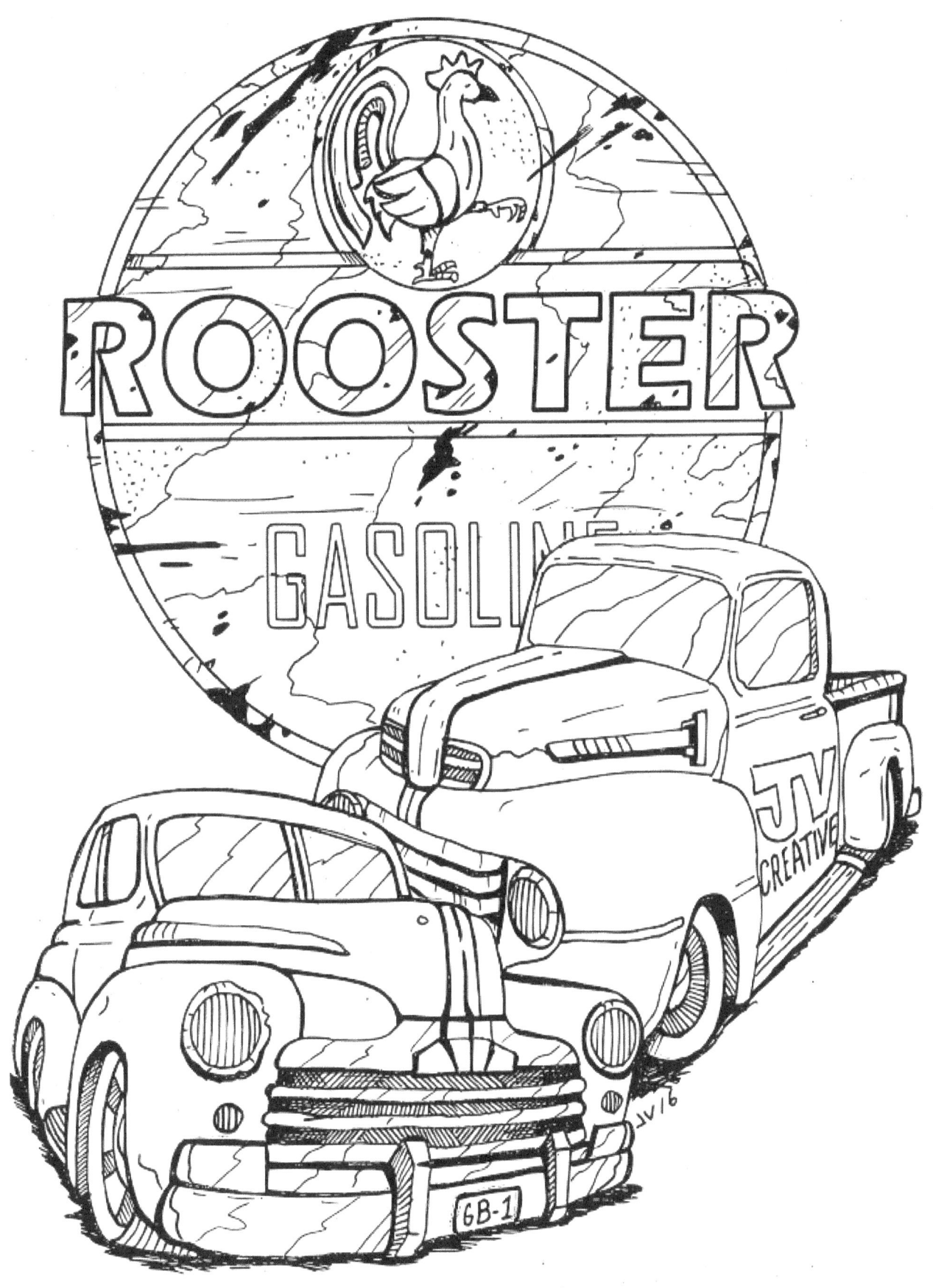

The following three pages are from Old Country Road Vol, I.

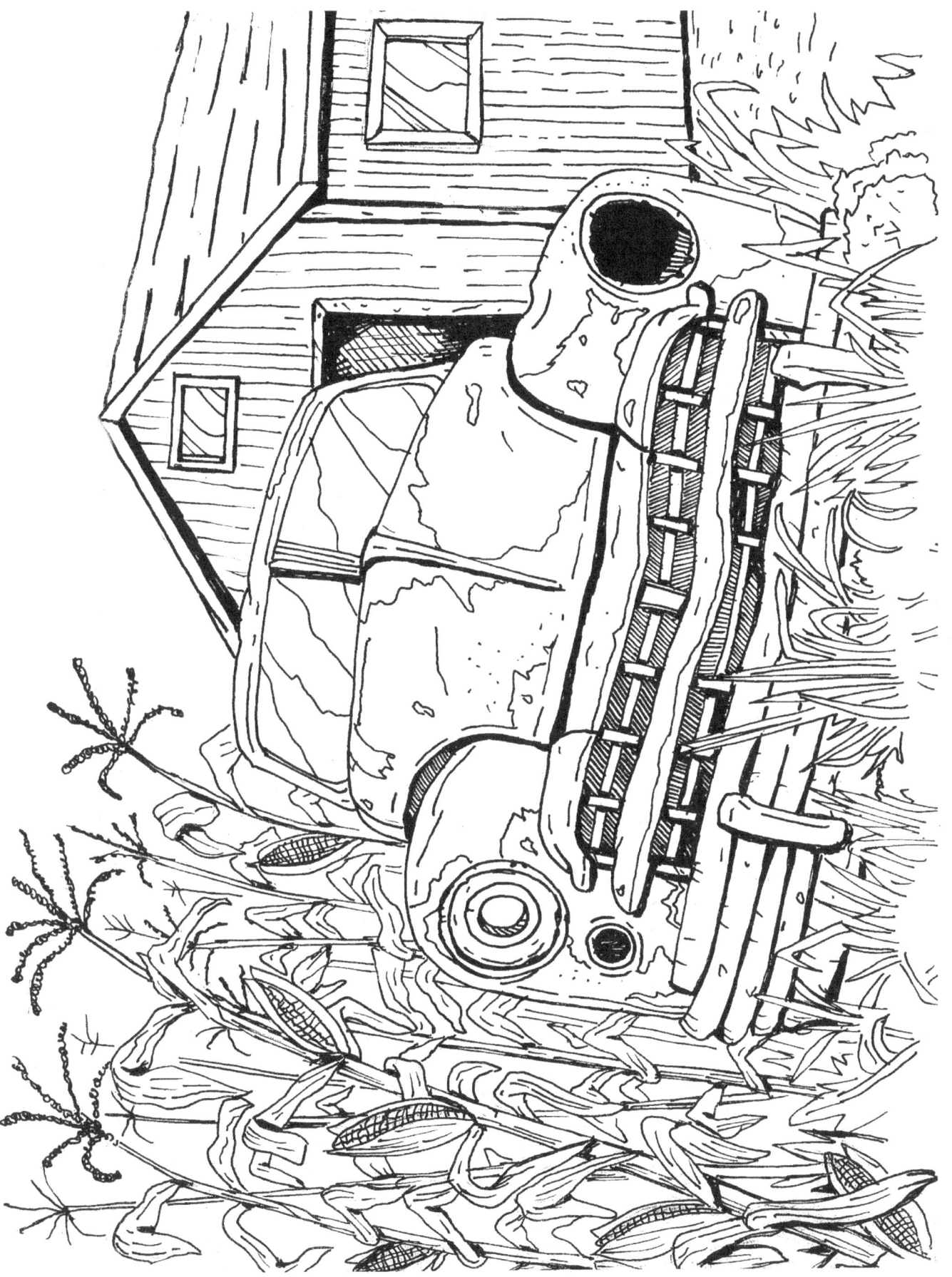

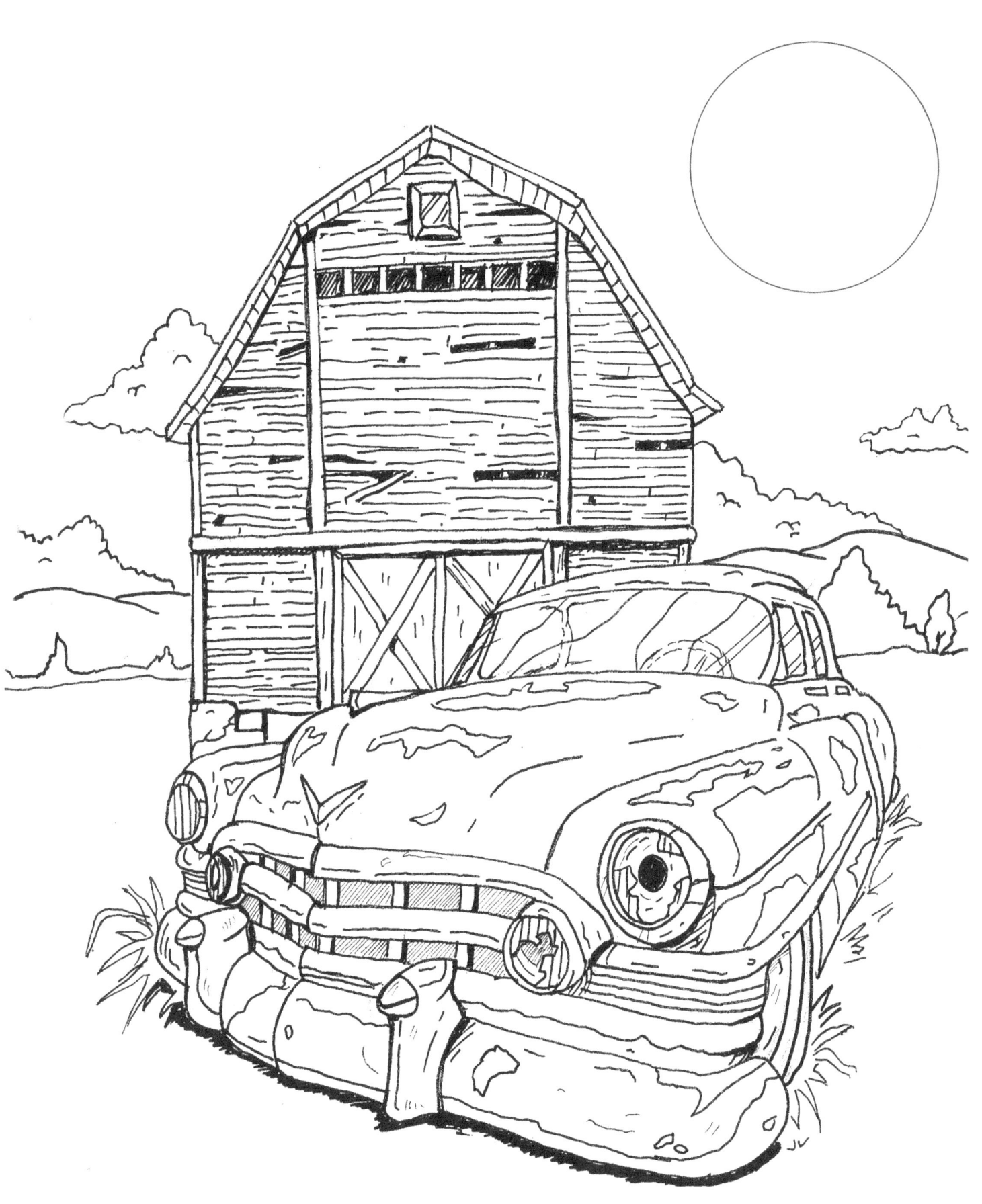

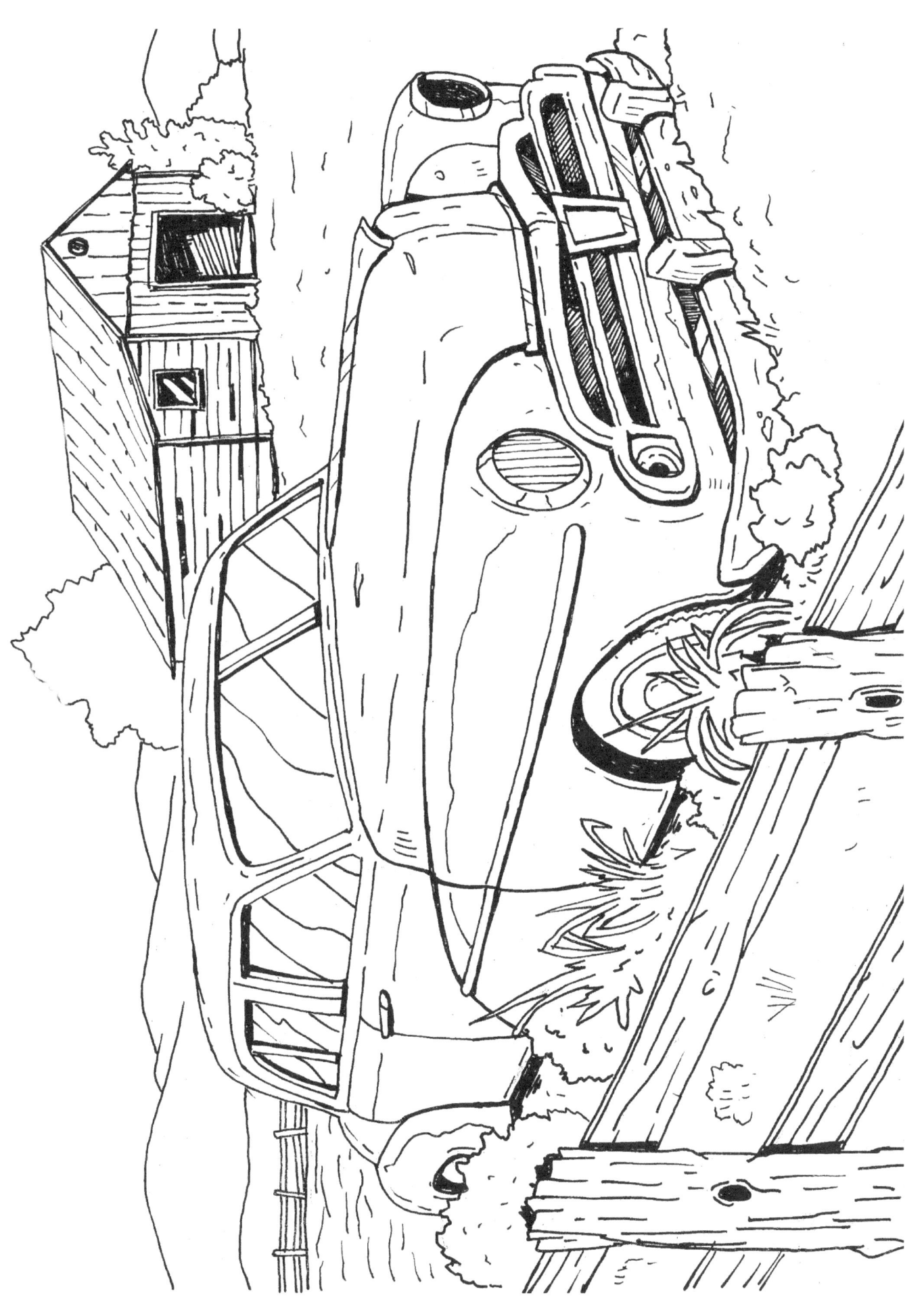

Bonus images by JV…..enjoy

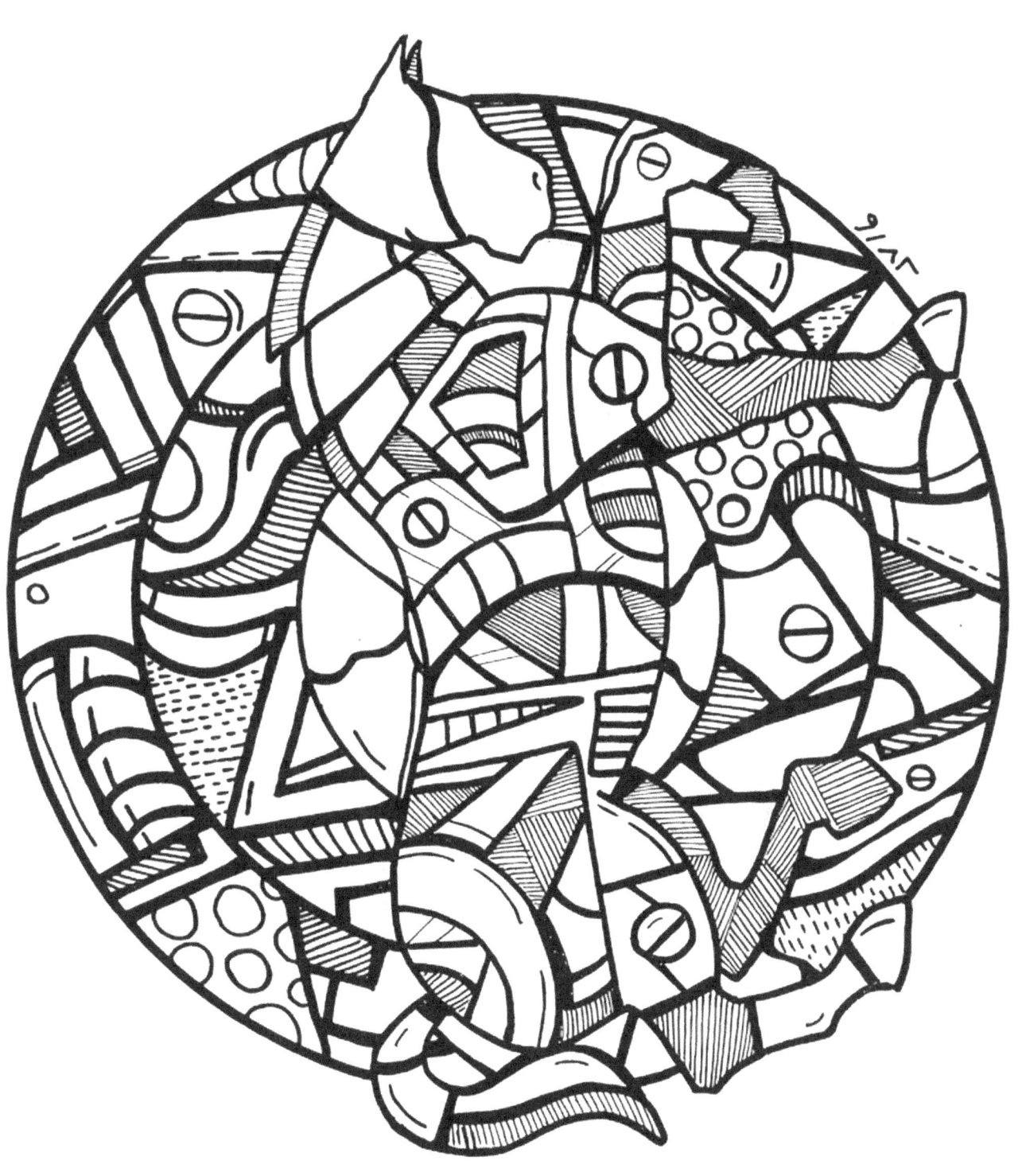

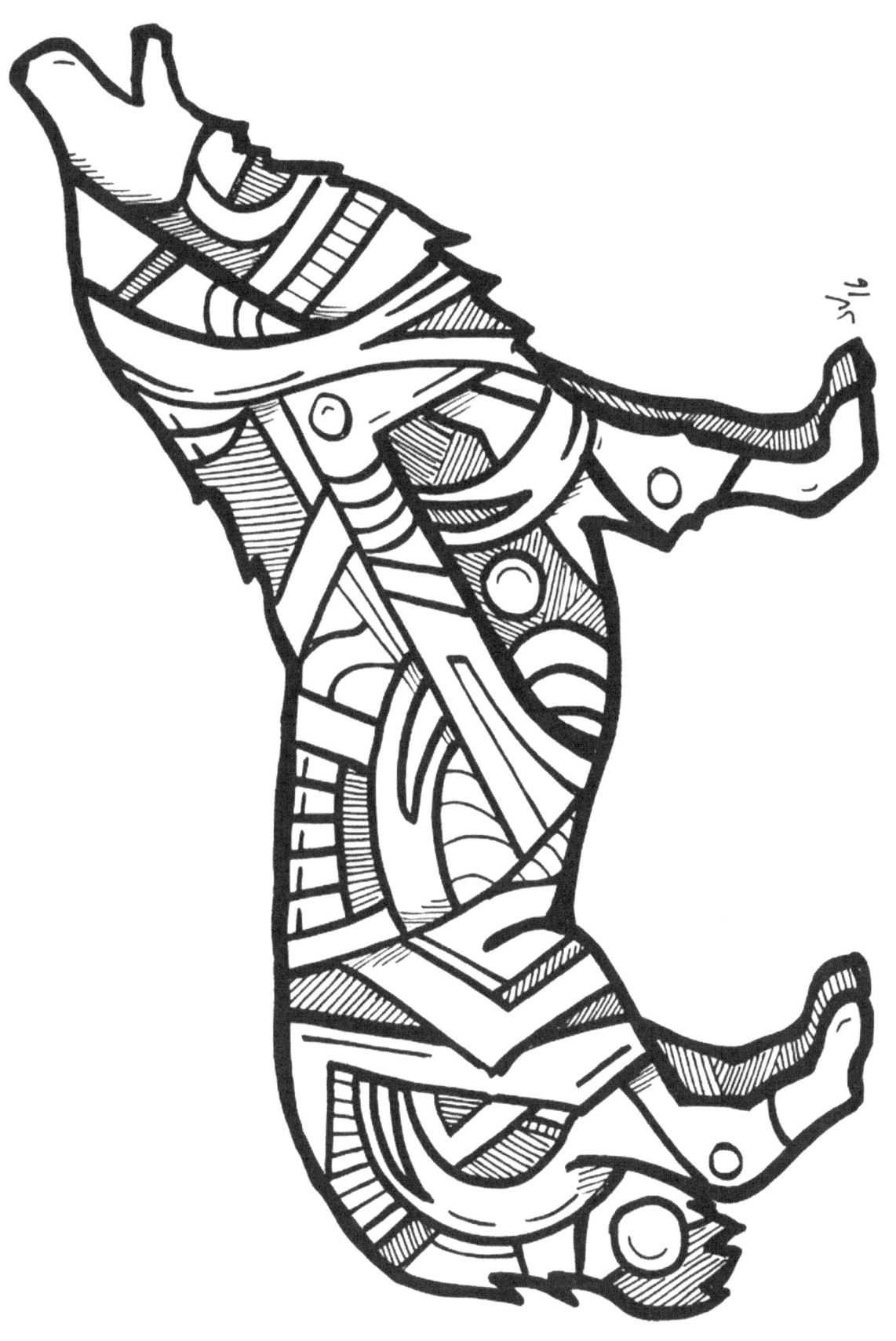

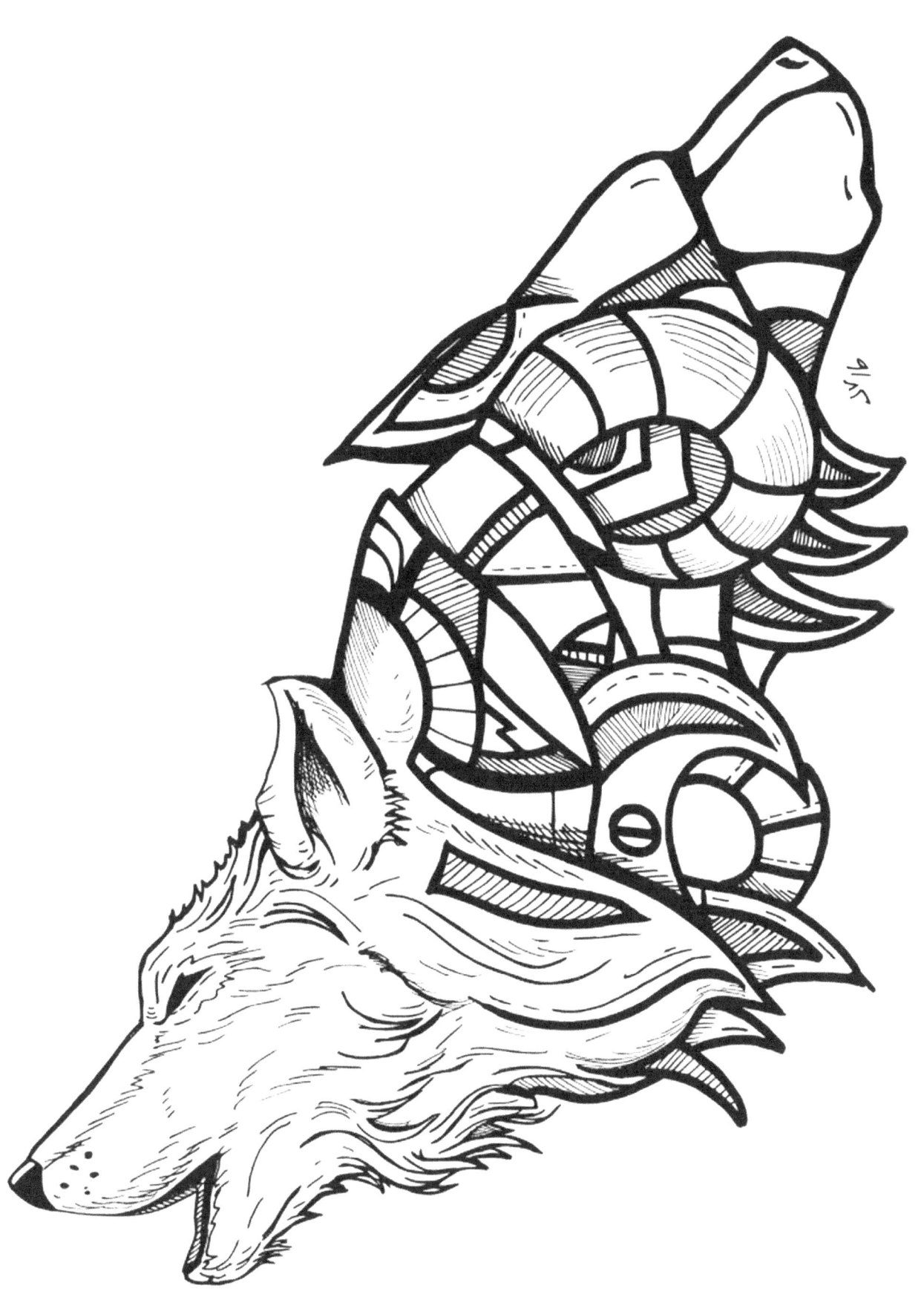

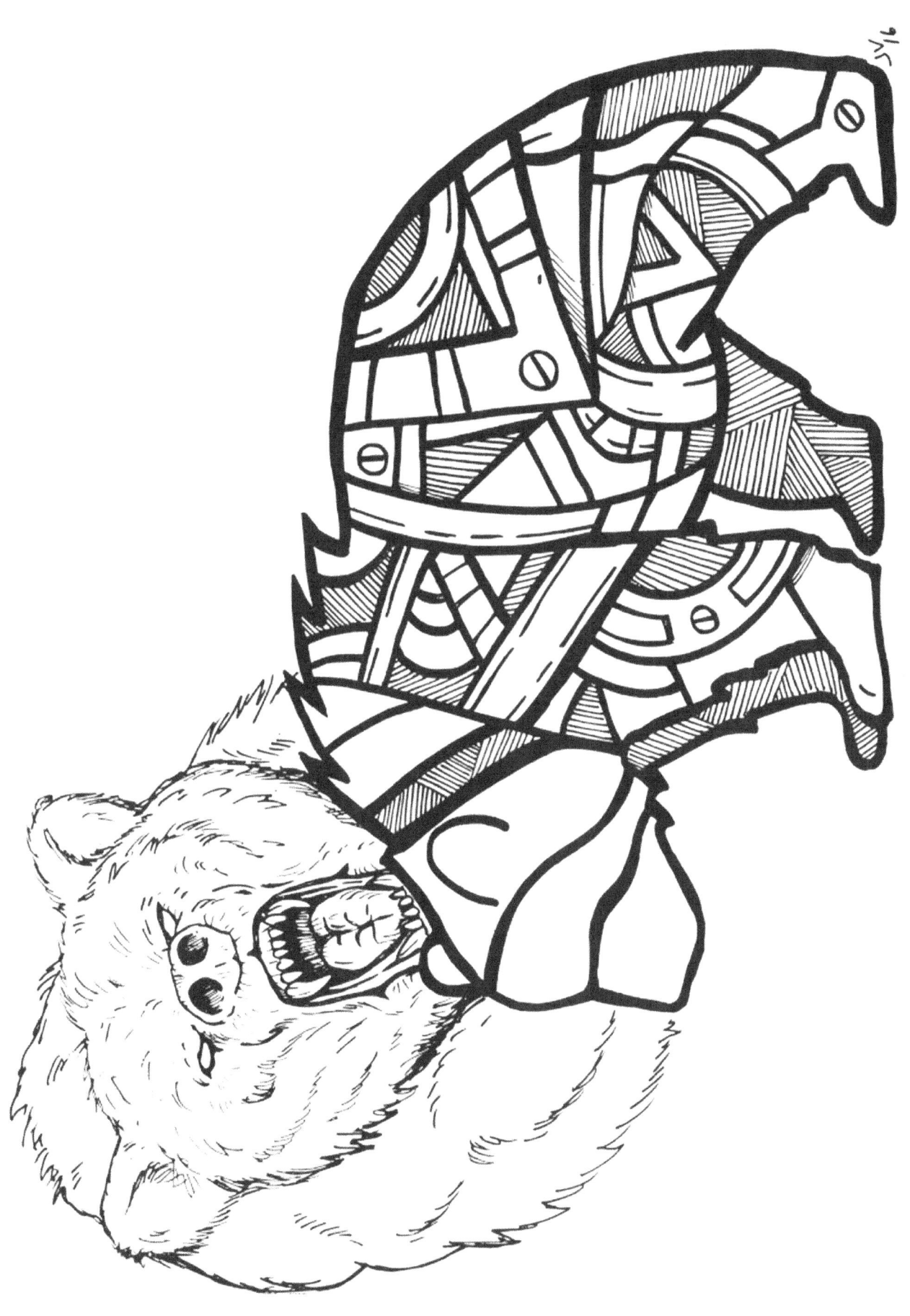

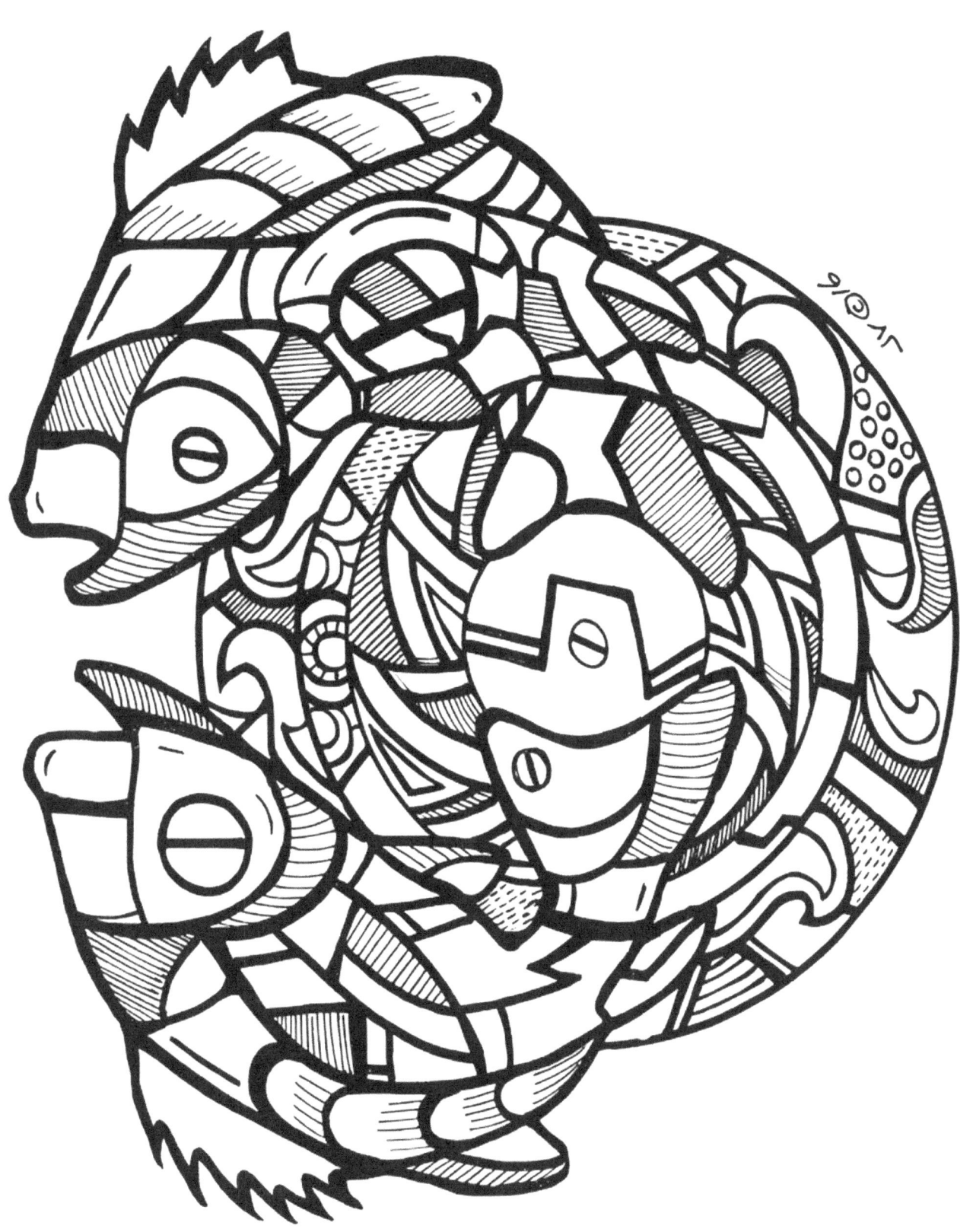

Hope that you enjoyed my art…..look for my other books now available.

Thank you, JV

Contact me at JVILLALBA1970@HOTMAIL.COM

www.ingramcontent.com/pod-product-compliance
Lightning Source LLC
Chambersburg PA
CBHW081253180526
45170CB00007B/2402